Futurism

In the 1920s and 1930s the term 'Futurism' was loosely used to describe a wide variety of aggressively 'modern' styles in art and literature. The word was in fact invented by an Italian poet called Filippo Tommaso Marinetti in 1910 for a movement, founded and led by himself, whose first and most vigorous phase was over by 1914. Futurism was the first deliberately organized, self-conscious 'movement' of the twentieth century; it appealed to all those who were tired of Romanticism and Decadence and sentimentality and wanted something more vigorous and robust, more in keeping with the Machine Age. Marinetti and his followers (who included Boccioni, Carrà, Balla, Severini) were intoxicated with speed, violence, noise, all the transient impressions and new sensations of life in the modern city; they despised all tame 'bourgeois' virtues and tastes, and above everything else loathed the cult of the past. In a series of manifestoes which were designed to shock and provoke the public they tried to formulate styles of painting, sculpture, music and poetry which would express these ideas. If their attempts to put their theories into practice leave something to be desired, they nevertheless opened up possibilities which are still being explored and developed today.

This book is a lively account covering the activity of the Futurists not only in painting and sculpture but also in the theatre, literature and politics. Their works are represented by over a hundred illustrations, their theories are given in quotations from their many manifestoes and writings, which vividly preserve the flavour of the movement and which can still provoke something of the irritation, outrage, amusement and admiration which they aroused at the time.

Cover design based on Umberto Boccioni's caricature of a Futurist evening in Milan, published in *Uno, due, e . . . tre* 17 June 1911

FUTURISM

Jane Rye

studio vista|dutton pictureback

general editor David Herbert

NX
600
· F8 R93
1972
C. 1

© Jane Rye 1972
Designed by Ian Craig
Published in Great Britain by Studio Vista
Blue Star House, Highgate Hill, London N19
and in the USA by E.P.Dutton and Co., Inc.
201 Park Avenue South, NY 10003
Set in Monotype Univers 8D, 2pt. leaded
Made and printed in Great Britain by
Richard Clay (The Chaucer Press) Ltd
Bungay, Suffolk

ISBN 0 289 70104 x (paperback)
 0 289 70105 8 (hardback)

Contents

445789

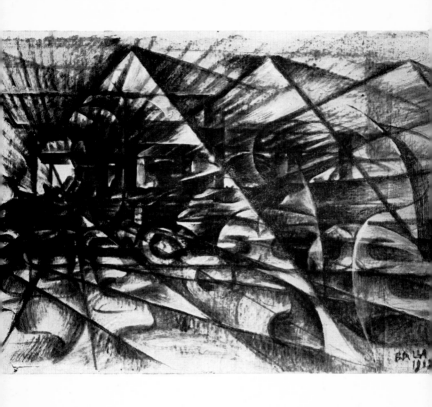

Giacomo Balla *Speeding Automobile* 1913 oil on paper 26 × 35½ in.
(66 × 90·2 cm.)
Galleria d'Arte Moderna, Milan

Futurism

We shall sing the love of danger, the habit of energy and boldness.

The essential elements of our poetry shall be courage, daring and rebellion.

Literature has hitherto glorified thoughtful immobility, ecstasy and sleep ; we shall extol aggressive movement, feverish insomnia, the double quick-step, the somersault, the box on the ear, the fisticuff. We declare that the world's splendour has been enriched by a new beauty : the beauty of speed. A racing motor-car . . . is more beautiful than the *Victory of Samothrace* . . .

There is no more beauty except in strife. No masterpiece without aggressiveness. Poetry must be a violent onslaught upon the unknown forces, to command them to bow before man. We stand upon the extreme promontory of the centuries ! . . . Why should we look behind us, when we have to break in the mysterious portals of the Impossible ? Time and space died yesterday. Already we live in the absolute, since we have already created speed, eternal and ever-present. We wish to glorify War—the only health giver of the world—militarism, patriotism, the destructive arm of the Anarchist, the beautiful ideas that kill, the contempt for women.

We wish to destroy the museums, the libraries, to fight against moralism, feminism, and all opportunist and utilitarian meannesses.

We shall sing of the great crowds in the excitement of labour, pleasure and rebellion ; of the multi-coloured and polyphonic surf of revolutions in modern capital cities ; of the nocturnal vibrations of arsenals and workshops beneath their violent electric moons ; of greedy stations swallowing smoking snakes ; of factories suspended from the clouds by their strings of smoke ; of bridges leaping like gymnasts . . . of broad-chested locomotives prancing on the rails like huge steel horses ; . . . and of the gliding flight of aeroplanes, the sound of whose screws is like the flapping of flags and the applause of an enthusiastic crowd.

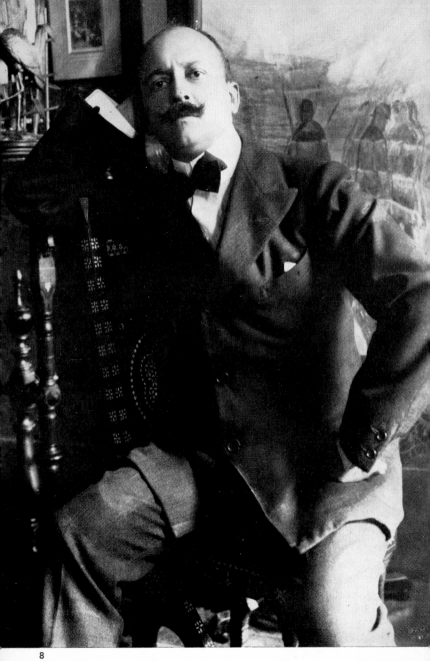

It is in Italy that we launch this manifesto of violence, destructive and incendiary, by which we this day found *Futurism*, because we would deliver Italy from its canker of professors, archaeologists, cicerones and antiquaries. Italy has for too long been the great market of the second-hand dealers. We would free her from the numberless museums which cover her with as many cemeteries.

. . . To admire an old picture is to pour our sensitiveness into a funeral urn, instead of casting it forward in violent gushes of creation and action . . .
For men on their death-bed, for invalids and for prisoners, very well! The admirable past may well be balsam to their wounds, since the future is closed to them . . . But we will have none of it—we, the young, the strong and the living *Futurists* !

Come, then, the good incendiaries, with their charred fingers! . . . Set fire to the shelves of the libraries! Deviate the course of canals to flood the cellars of the museums! . . . Seize pick-axes and hammers! Sap the foundations of the venerable cities! The oldest among us are thirty; we have, therefore, ten years at least to accomplish our task. When we are forty, let others, younger and more valiant, throw us into the wastepaper basket like useless manuscripts . . . And Injustice, strong and healthy, will burst forth radiantly in their eyes. For art can be nought but violence, cruelty and injustice.

. . . Your objections? Enough! Enough! I know them! It is agreed! We know well what our fine and false intelligence tells us. We are, it says, only the summary and the extension of our ancestors. Perhaps! Very well! . . . What matter? . . . We stand upon the summit of the world, and once more we hurl our challenge to the stars!
(Marinetti, Foundation Manifesto of Futurism, published in *Le Figaro* 20 February 1909)

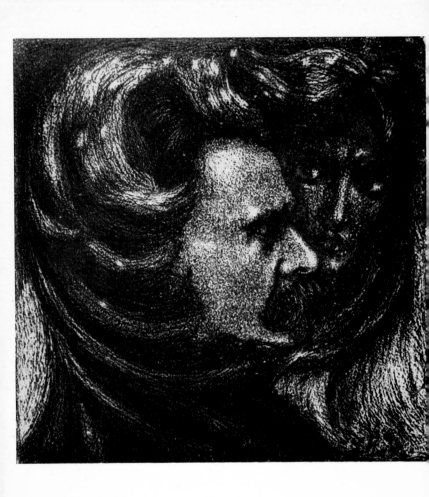

Luigi Russolo *Nietzsche c.* 1909 etching $4\frac{7}{8} \times 5$ in. (12·4 × 12·7 cm.)
Galleria d'Arte Moderna, Milan

Futurism was an Italian movement which began in 1909 and flourished until about 1915. It is not an 'art movement' in the ordinary sense, but (like the Dada and Surrealist movements of which it was a precursor) more of an ideology, a way of approaching modern life. It was founded, led, financed and stage-managed by Filippo Tommaso Marinetti, a rich Italian poet of Alexandrian extraction, well known in the *avant-garde* literary circles of Paris, and editor of the controversial review *Poesia* (1905–9), which was published from his luxurious home in Milan. But although Futurism began in literature, and remained at heart a literary movement, it spread quickly to the other arts, and indeed to every aspect of life that it could reach.

Its basic themes were established in Marinetti's Foundation Manifesto: the exaltation of speed, youth and action; of violence and conflict; rebellion against the past and disgust with the stagnation of Italian culture; a passionate enthusiasm for the beauties of the industrial age. Many responded to Marinetti's rallying cry; others, in a carping spirit, pointed out that there was nothing very new in all this, which was undoubtedly true. Belief in the power and virtue of youth had been strong in the nineteenth century, since the Romantic movement, and particularly so in Italy where Mazzini's Italian Youth had been such a powerful political force. Many writers, and to a lesser extent painters, had observed the beauty of machines and the artistic possibilities of the industrial age since Baudelaire had exhorted the artist to concern himself with 'the heroism of modern life'; long before Futurism exasperated artists had badly wanted to set fire to the Louvre and had publicly suggested doing so. The belief in the healthiness of war and violence and injustice, and in the rights of the strong and vigorous over the weak, comes straight from Nietzsche, whose ideas were popular in both Italy and France at the time; and Georges Sorel was preaching violence as a political doctrine to the Syndicalists.

Among the most distinguished of those who complained of Marinetti's lack of originality was the group of intellectuals, led by Giovanni Papini, Giuseppe Prezzolini and Ardengo Soffici, who formed the so-called Florentine Movement. These men had for some years been campaigning against the moribund state of Italian cultural life, and trying, in their review *Leonardo* (1903–7) and then in *La Voce* (1908–16), to bring Italy back into the mainstream of European culture by introducing the public to new ideas

Photograph of Giovanni Papini *c.* 1914

and artistic trends from France and elsewhere. 'It is an *aut-aut*
which the soul of the nation must decide upon', wrote Papini and
Prezzolini in *La Coltura Italiana* in 1906 : 'a To be or not to be . . .
Either gather the courage to create the third great Italy—not the
Italy of the popes or of the emperors, but the Italy of the thinkers,
the Italy which has not existed so far—or only leave behind a wake
of mediocrity which will instantly vanish in a gust of wind.' They
realized the importance of Marinetti's first manifesto, and under-

stood the value of Futurism as a revitalizing force, but their own methods of persuasion were more sober, and they were repelled by the brashness and belligerence of Marinetti's language. During the next couple of years the Florentine group produced the sharpest and most discerning criticism of the Futurists, who retaliated with spirit (on one famous occasion, in 1911, they were incited to physical violence by Soffici's criticism of Futurist paintings, and took train from Milan to Florence especially to assault him as he sat peacefully drinking coffee with his friends). But in spite of their public hostility to Futurism, in which there was probably an element of inter-city rivalry, the Florentines had to grant that Marinetti's organization and propaganda methods were doing more to achieve their common ends than their own efforts, from a city 'which deliberately suffocates all vigorous life with its provincial narrow-mindedness and its *passéist* bigotry', could do, and the two movements eventually joined forces. Papini, as philosopher and polemicist, and Soffici as painter and artistic theorist, officially became Futurists in 1913, and in the year or so of their allegiance to the movement they made valuable contributions to Futurist theory and added considerably to its prestige.

Inevitably, the movement was from the outset involved in politics. Its driving ambition was to make Italy once again a force to be reckoned with, both politically and culturally. The Futurists wanted Italy to be respected for her present and not merely for her past, and Futurism was to play a double role. Firstly it was to introduce a new aesthetic which would express the mental and physical sensations of life in the Machine Age, demonstrating that Italians could be admired for what they could do now, as well as for what they had done in the past (and incidentally that the French were not the only people capable of producing startling new ideas). Secondly, it was to shock, ridicule and provoke the Italian public and the custodians of Italian culture out of their complacent lethargy and to inspire them to create an up-to-date Italy which would be as great as the Italy of classical antiquity and of the Renaissance and yet in no way dependent on them. In order to create this new Italy it was necessary to shake off completely the dead hand of the past. Italian culture was based on past glories and stultified by tradition. From now on it must be inspired by the achievements of science and technology, and reflect the 'dynamism' of modern life. 'I am a Futurist', wrote

Papini (*L'Esperienza Futurista*, 1913), 'because Futurism means Italy, an Italy greater than the Italy of the past, more modern, more courageous, more advanced than other nations. The most lively flame of this Italy burns brightest amongst the Futurists, and I am proud of being one of them.'

Unlike the rest of Europe, Italy was only just beginning to emerge as a single nation: for centuries it had been divided and under foreign domination. Italians were at last beginning to feel proud of being Italians, rather than of being Sienese or Florentine, and competitiveness sought a wider field than the traditional rivalry between one city and another. In the fields of industry and technology Italy had been a good hundred years behind England, Germany and France, but in the first decade of this century the process of industrialization was tremendously accelerated. Italy felt that it was no longer out on a limb, that it had more to offer than the relics of its past greatness, and that it was at last in a position to compete with the rest of Europe. The new mood of national confidence and aggressiveness was expressed politically in Italy's desire to disengage itself from Austria, under whose rule the North of Italy had lain for so long, and the Triple Alliance, and to turn towards France and England; and in the desire for colonial expansion (gratified in the Tripoli campaign of 1911). Culturally, the mood was expressed by the rise of Futurism.

Marinetti, however, despite his intense nationalism, was very much a cosmopolitan; from the outset he was intent on reaching as wide an audience as possible, and one of the most striking things about the Futurist movement is the speed with which its ideas were spread all over Europe. The Foundation Manifesto was published in Paris, on the front page of *Le Figaro*, and so was given, from the point of view of publicity and prestige, the best possible start in life. Italy's cultural centres were still provincial, and there was no city in which a manifesto could be published and hope to arouse much interest elsewhere. But Paris exerted a powerful snob-appeal throughout the western world, and a movement launched there would inevitably attract attention everywhere it was wanted. Thereafter, Futurism was organized somewhat on the lines of a modern political campaign. Marinetti had all the qualifications for a successful entrepreneur: plenty of money and effrontery; boundless energy, a large circle of acquaintances and a good deal of personal charm. Recalling one of his appearances in London, C.R.W.Nevinson writes: 'Most

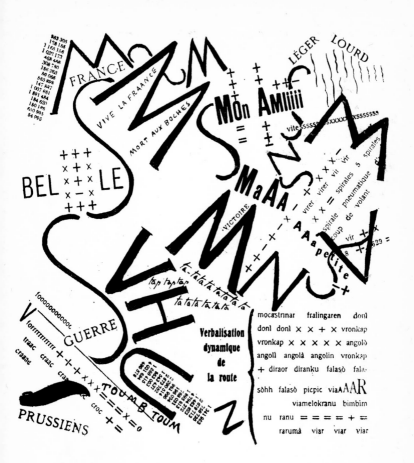

F.T.Marinetti *Montagne +Vallate + Strade × Joffre* (*Mountains + Valleys + Streets × Joffre*) free-word composition broadsheet 1915

F.T. MARINETTI Volontario
Corso Venezia 61 - Milano
VIMENTO FUTURIST

TIPO-CANGIULLO

LETTERA-FUTURISTA

DATA	DESTINATARIO *F. Cangiullo*

F U T U R I S M O
Felice sapere Vela Latina futurista o quasi. Tutto merito tuo Lodo

G U E R R A
Romani tornare al fuoco Sensazioni enormi nuove

P I A C E R I
desiderio ricevere ogni giorno tue notizie

N O V I T À
desiderio sapere se Balla Ti scrive.

D O N N E
(Zero)

V I A G G I (RENDEZ-VOUS)
desiderio venire Napoli lavorare con te. DOPO

S A L U T I (RINGRAZIARE)
mandarmi molte molte molte lettere Tipo Cangiullo. Ho tutto spedito

TOTALE = impazienza FIRMATO Tuo F.T.

A letter from F.T.Marinetti to Francesco Cangiullo from the Front
From *Sipario* no. 269 December 1967. The Futurist letter form was invented
by Cangiullo.

people had come to laugh, but there were few who were not overwhelmed by the dynamic personality and declamatory gifts of the Italian propagandist . . .'; Papini describes his arrival in Florence as like 'a meteorite landing in an old palace garden Telegrams, telephone calls, rides in motor cars, appointments made and put off, tumultuous dinner parties, mass invasions of respectable cafés . . .' (C.R.W.Nevinson, *Paint and Prejudice*, 1937; G.Papini, *Passato Remoto*, 1948). He made what might be described as whistle-stop tours throughout Europe, lecturing, reciting Futurist poetry, declaiming manifestoes, organizing Futurist demonstrations of one sort or another. Up and down Italy theatres were hired for 'Futurist evenings', which usually ended in brawls, spontaneous or otherwise. Marinetti and his followers were in favour of violence, both for its own sake and for its publicity value, and it was not unusual for Futurists to find themselves spending the night in prison after one of these riotous entertainments. Less spectacularly, but probably more significantly, Futurist doctrines were promulgated through the publication and distribution of manifestoes. Marinetti's organization seems to have been remarkably efficient: the most important of them were published more or less simultaneously in Italian and French; they would be printed in newspapers and periodicals in both countries, and distributed as broadsheets; before long they were translated into German, English, Spanish and Russian. It was a time when art was news, and the extravagant behaviour of the Futurists, their extraordinary, often ludicrous and always well-publicized ideas very quickly made them notorious, and were discussed in articles serious, outraged or indulgently amused, in newspapers and journals all over Europe, in Russia and America, and even in such a seemingly unlikely place as Japan.

Painting and sculpture

On 8 March 1910, the Manifesto of Futurist Painters was proclaimed from the stage of the Teatro Chiarella in Turin. The manifesto was signed by five painters: Umberto Boccioni (Milan), Carlo Carrà (Milan), Luigi Russolo (Milan), Giacomo Balla (Rome) and Gino Severini (Paris). They later referred to it as 'a violent and cynical cry' in the utterance of which 'we exchanged almost as many knocks as we did ideas', but although it was certainly belligerent, and the occasion a stormy one, the manifesto—addressed 'To the young artists of Italy'—was no more than a reiteration, in rather less visionary language, of the main points of Marinetti's Foundation Manifesto: repudiation of the past; enthusiasm for 'all that is young, new and pulsating with life'; insistence that the artist draw his inspiration from the contemporary world; and concern for the regeneration of Italian culture. 'In the eyes of other nations', wrote the Futurist painters, 'Italy is still a land of the dead, an immense Pompeii, white with sepulchres. But Italy is being reborn, and her political rebirth is followed by an intellectual rebirth.' Critics were denounced as 'complacent pimps'; academies, archaeologists, professors, traditional painters—all the so-called custodians of culture—were scathingly attacked. Among the aims they announced were the determination 'to destroy the cult of the past, obsession with antiquity, pedantry, and academic formalism ... To despise profoundly any form of imitation ... To exalt every form of originality, even if rash, even if extremely violent.'

Shortly afterwards, on 11 April 1910, the painters published a more precise declaration of what Futurist painting was to be. The Technical Manifesto of Futurist Painting set out 'to expound with technical precision our programme for the renovation of painting'. It is one of the most important of the Futurist statements, not only for painting but for the movement as a whole, because it elaborated and explained in some detail the concept of 'dynamism', briefly indicated by Marinetti in the Foundation Manifesto, which is the corner-stone of the Futurist aesthetic.

Giacomo Balla *Mercury Passing before the Sun* 1914 tempera on paper laid on canvas 59 × 38 in. (149·9 × 96·5 cm.)

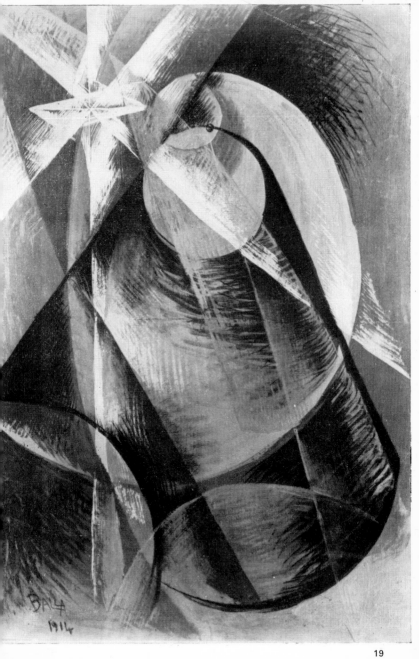

The gesture which we would reproduce on the canvas shall no longer be a fixed *moment* in universal dynamism. It shall simply be the dynamic sensation itself made eternal. A profile is never motionless before our eyes, but it constantly appears and disappears. On account of the persistence of an image upon the retina, moving objects constantly multiply themselves; their form changes like rapid vibrations, in their mad career. Thus a running horse has not four legs, but twenty, and their movements are triangular . . .

The sixteen people around you in a rolling motor-bus are in turn and at the same time one, ten, four, three; they are motionless and they change places; they come and go; they bound into the street, are suddenly swallowed up by the sunshine, then come back and sit before you, like the persistent symbols of universal vibration . . . The vivifying current of science must soon deliver painting from academic tradition . . . All subjects previously used must be swept aside in order to express our whirling life of steel, of pride, of fever and of speed.

Science has provided artists with vast new fields to explore, and new eyes to see with; the painter now

carries within himself all the landscapes which he wishes to fix upon his canvas . . . Who can still believe in the opacity of bodies since our sharpened and multiplied sensitiveness has already penetrated the obscure manifestations of the medium? Why should we forget in our creations the doubled power of our sight, capable of giving results analogous to those of the X-rays?

A painter who pretends still to see things as they were seen by painters in the past is guilty of a falsehood. If the painter looks at the world with the 'sincerity and virginity' essential for the interpretation of nature, he will see, for instance, that

Space no longer exists: The street pavement, soaked by rain beneath the glare of electric lamps, becomes immensely deep and gapes to the very centre of the earth. Thousands of miles divide us from the sun; yet this house in front of us fits into the solar disc! . . .

Our bodies penetrate the sofas on which we sit, and the sofas penetrate our bodies. The motor-bus rushes into the houses which it passes, and in their turn the houses throw themselves upon the motor-bus and are blended with it.

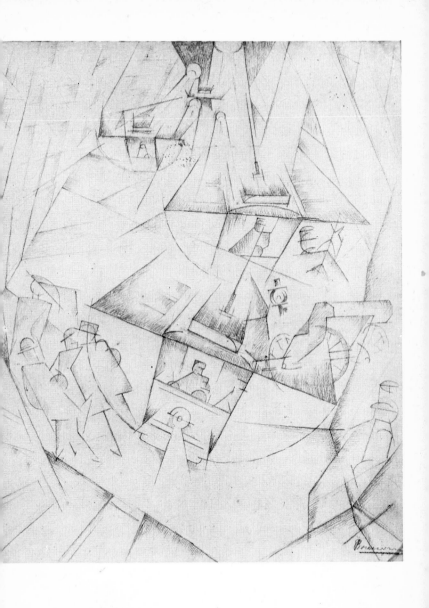

Umberto Boccioni, study related to *The Forces of a Street* 1911 pencil
17¼ × 14⅝ in. (43·8 × 37·1 cm.)
Civico Gabinetto Disegni, Milan

Caricature of Futurist dynamism
From *Travaso* 1913

These are the kind of 'dynamic sensations' with which painting must render the universal dynamism, and for their full impact to be felt, the spectator must not be allowed to view the painting from a safe distance—Futurist painters will henceforth construct their works so as to 'put the spectator in the centre of the picture'. Similarly, the artists themselves wanted 'at any price to re-enter life. Victorious science has nowadays disowned its past in order the better to serve the material needs of our time; we would that art, disowning its past, were able to serve at last the intellectual needs which are within us.'

Their 'renovated consciousness', however, did not permit them any longer to regard man as 'the centre of universal life . . . The suffering of a man is of the same interest to us as the suffering of an electric lamp, which, with spasmodic starts, shrieks out the most heartrending expression of colour.'

Colour was to be an important element in the new painting. As soon as the eye was freed from its 'veil of atavism and culture' and could at last:

look upon Nature and not upon the museums as the one and only standard . . . it will readily be admitted that brown tints have never coursed beneath the skin; it will be discovered that yellow shines forth in our flesh, that red blazes, and that green, blue, and violet dance upon it with untold charms . . .

How is it possible still to see the human face pink, now that our life, redoubled by noctambulism, has multiplied our perceptions as colourists . . . The pallor of a woman gazing in a jeweller's window is more intensely iridescent than the prismatic fires of the jewels that fascinate her.

The time has passed for our sensations in painting to be whispered. We wish them in future to sing and re-echo upon our canvases in deafening and triumphant flourishes.

Nothing in the Futurist painters' previous work had prepared them for the tasks they set themselves in their Technical Manifesto. Futurist painting did not grow naturally out of previous experiments. Stimulated by Marinetti's ideas and their own discontent with the artistic establishment, they tried to develop a wholly new art, beginning from scratch, and it must be admitted that they failed. In the process they developed theories which were

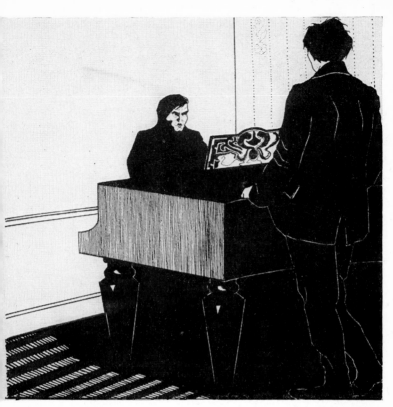

Umberto Boccioni *Pianist and Listener c.* 1907 ink drawing 7 × 7¼ in.
(17·8 × 18·4 cm.)
Collection Mrs Barnett Malbin (Lydia and Harry Lewis Winston Collection),
Birmingham, Mich.

Luigi Russolo *Music* 1911 oil on board 86½ × 53½ in. (219·7 × 135·9 cm.)
Collection Eric Estorick, London

original and undoubtedly influential, but these theories far out-
stripped their practice, and their works are for the most part naïve
and superficial translations of ideas which are essentially literary.
When at last the painters did find, in Cubism, a style that they
could adapt for their own purposes and their painting became
correspondingly more assured, they seemed to lose sight of the
expressive aims with which they had set out, and to become

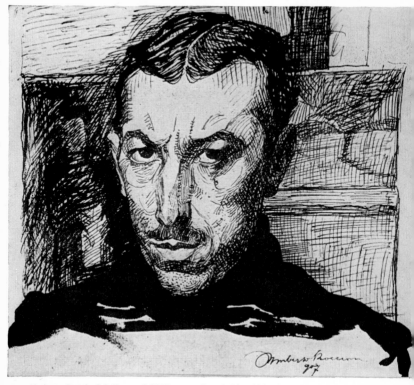

Umberto Boccioni *Self portrait* 1907 pen and wash 8¼ × 8¼ in. (21 × 21 cm.)
Raccolta Paulucci, Turin

more and more absorbed in the formal problems suggested by
Cubism. It would be tempting to illustrate an account of Futurist
painting with works by contemporary artists not directly attached
to the movement, which so often seem to express successfully
what the Futurists were groping after.

The two most advanced styles current in Italy at the time were
Divisionism (the Italian version of the Neo-Impressionism of
Seurat and Signac) and Art Nouveau, and it was within the
context of these two styles that the painters had worked and
experimented before they were caught up in the Futurist whirl-
wind. They all felt the need for something new. Boccioni wrote
in his diary in 1907: 'I must confess that I seek, seek and seek and
do not find . . . I feel that I wish to paint the new, the fruits of our

industrial age, I am nauseated by old walls, and old palaces, and by old motifs, by reminiscences. I wish to have the life of today in front of my eyes . . . It seems to me that today art and artists are in conflict with science . . . Our feverish epoch makes that which was produced yesterday obsolete and useless.' He was perhaps the one who felt the need most passionately; he was certainly the most energetic and restless of the Futurist painters, and their acknowledged spokesman and leader; and he is usually spoken of as the most talented of the group (Apollinaire said he was in 1912). Boccioni was also responsible for inviting Balla and Severini to join Futurism. He and Severini had been taught the Divisionist technique by Balla, who was an older man with quite an established reputation by 1910. Balla and Severini, the one in Rome and the other in Paris, worked rather in isolation from the rest of the group, and indeed Balla contributed little to the movement and took no part in its activities until 1913.

The three artists chosen as heroes by the Futurist painters in their first manifesto were the Divisionist painters Giovanni Segantini and Gaetano Previati, and the Impressionist sculptor Medardo Rosso. It is true that they were chosen largely as weapons with which to attack the critics, who had failed to appreciate their art, but nevertheless Divisionism and Impressionism were the chief sources of Futurist ideas and technique in the early stages of the movement (although Symbolist and Art Nouveau elements are also apparent, particularly in the work of Russolo). In 1909 and 1910 Ardengo Soffici wrote several articles on Impressionism, and on Medardo Rosso in particular, which were read by the Futurists. According to Soffici, Rosso held:

that sculpture should not be condemned to produce solely beautiful forms isolated in space and enclosed by definite, static, certain lines; forms are thus almost imprisoned in a profile of immobility, shaved off from the whirling centre of universal life, remaining there stiff and still to be examined from all sides by curious spectators . . . The movements of a figure must not stop with the lines of contour . . . but the intensity of the play of values and the protrusions and lines of the work should impel it into space, spreading out to infinity the way an electric wave emitted by a well-constructed machine flies out to rejoin the eternal force of the universe (Ardengo Soffici, *Il Caso Medardo Rosso,* 1909).

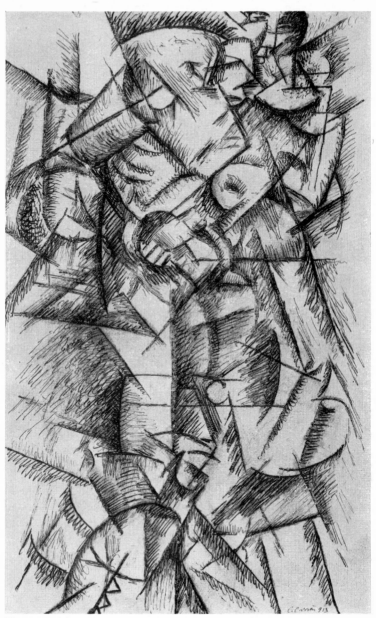

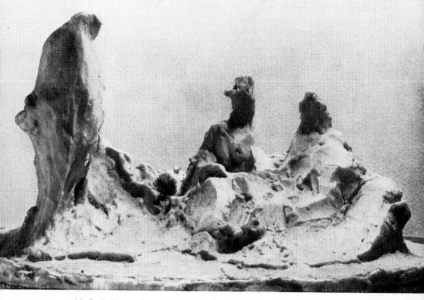

Medardo Rosso *Conversation in a Garden* 1893 wax over plaster
17 in. (43·2 cm.) h.
Collection Dr Gianni Mattioli, Milan

◄ Carlo Carrà *The Boxer* 1913 pen and ink on card 17¾ × 11 in.
(44·1 × 28·9 cm.)
Collection Eric Estorick, London

Rosso himself had written that 'nothing is material in space', and
the curious melted contours of his *Man Reading a Newspaper* or
Conversation in a Garden were an attempt to show that figures
were a part of the surrounding atmosphere. These ideas are
repeated in the Technical Manifesto, where the painters declared
that 'Movement and light destroy the materiality of bodies' and
that 'To paint a human figure you must not paint it; rather you
must render the whole of its surrounding atmosphere.'

The first fruits of Futurist painting were seen at the enormous
Free Exhibition in Milan in April 1911.

If you do not want to cover yourself with shame, giving proof
of ignominious intellectual apathy unworthy of the high
Futurist destiny of Milan, rush and intoxicate your spirit before

Umberto Boccioni *Mourning* 1910 oil on canvas 41½ × 53 in.
(105·1 × 134·6 cm.)
Collection Mrs Margarete Schultz, New York

fifty *Futurist paintings* which the *Corriere della sera* calls
'THE MADDEST COLOURISTIC ORGIES, THE MOST INSANE
ECCENTRICITIES, THE MOST MACABRE FANTASIES, ALL
THE DRUNKEN FOOLISHNESS POSSIBLE OR IMAGIN-
ABLE'

cried the painters, although the paintings they had produced by
this date do not seem quite to justify such a description. Works
such as Boccioni's *Mourning*, Russolo's *Perfume* or Carrà's
Nocturne in the Piazza Beccaria, are not particularly 'Futurist'
either in subject or treatment; the technique is still based more
or less on Divisionism, and it is difficult to see in them much
30

Luigi Russolo *Perfume* 1910 oil on canvas 25½ × 24¾ in. (64·8 × 62·9 cm.)
Collection Mrs Barnett Malbin (Lydia and Harry Lewis Winston Collection),
Birmingham, Mich.

attempt to put the ideas of the Technical Manifesto into practice.
Boccioni's powerful evocation of grief, it is true, does convey that
emotion without relying on the anecdotal ('The ideal for me
would be a painter who, wanting to evoke sleep, would not
associate himself with the mind of the being (man, animal, etc.)
sleeping, but would be able by means of lines and colours to
evoke the *idea* of sleep, that is *universal sleep*, beyond the
accidentality of time and place', he wrote in a letter of 1910), and
so can be said to render the 'dynamic sensation' of grief; and a
further effort to prevent the painting from representing a 'fixed
moment in the universal dynamism' is made by showing the same
figure in different attitudes of affliction; but this effect is not

31

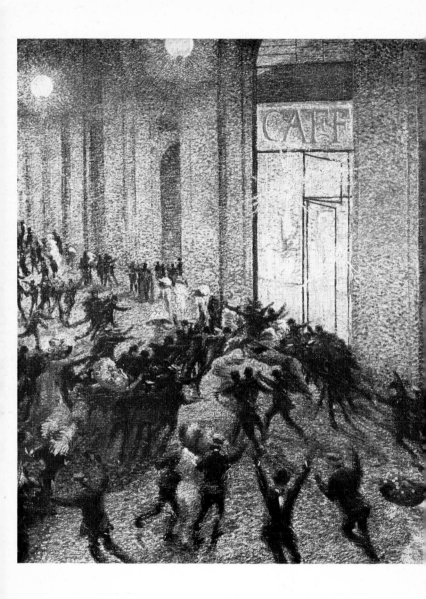

Umberto Boccioni *Riot in the Galleria* 1910 oil on canvas 30 × 25¼ in.
(76·2 × 64·1 cm.)
Collection Dr Emilio Jesi, Milan

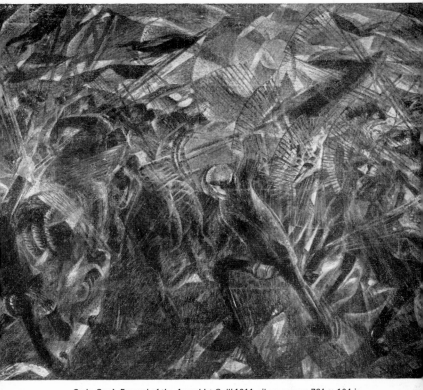

Carlo Carrà *Funeral of the Anarchist Galli* 1911 oil on canvas 78¼ × 104 in.
(198·8 × 162·6 cm.)
Museum of Modern Art, New York

emphasized by the composition, and indeed can easily pass
unnoticed. Russolo's picture is an attempt to find a visual method
of representing a non-visual sensation, which is certainly one of
the things with which Futurism was to concern itself, but other-
wise it might almost have been designed as a provocation to
Marinetti, who had just written a fierce condemnation of '. . . the
abandon of half-parted lips, drinking in twilight nostalgia', etc.,
in his novel *Mafarka il futurista* and is hardly in keeping with the
robust Futurist attitude to women.

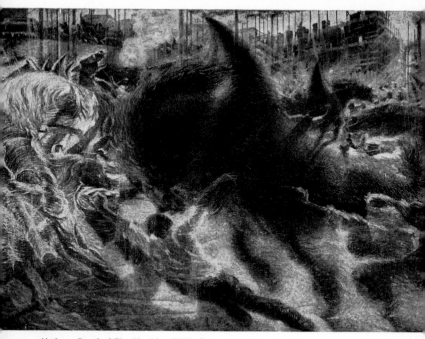

Umberto Boccioni *The City Rises* 1910 oil on canvas 78½ × 118½ in.
(199·4 × 301·9 cm.)
Museum of Modern Art, New York

A start was made, however, with the so-called 'Unanimist' paintings completed in time for the Free Exhibition, towards something more approaching an expression of the Futurist spirit. Even the titles of these works sound more promising: in *Riot in the Galleria* Boccioni succeeds in conveying the collective excitement and movement of a crowd, although it is still from a distance, and there is no attempt to 'put the spectator in the centre of the picture'. This is better achieved in Carrà's *Funeral of the Anarchist Galli* (re-worked, particularly in the upper part, after the artist's contact with Cubism in 1912) and in Boccioni's *The City Rises*, in which he strove for 'a great synthesis of labour, light and move-

Carlo Carrà *Leaving the Theatre* 1910/11 oil on canvas 35½ × 27¾ in.
(90·2 × 70·5 cm.)
Collection Eric Estorick, London

ment'. This painting, the most important of his early Futurist
works, on which he worked a long time, has a shimmering, mirage-
like quality with its brilliant white-hot colours and forms dis-
solved and disembodied by light, but the effect of powerful
forces is conveyed through attitudes of violent movement con-
ventionally represented, and the picture remains on the whole
sentimental and rhetorical. Carrà confined himself to the rather
less intense sensations to be experienced in city streets, and
his *Leaving the Theatre* (of which he later remarked, in *La Mia
Vita,* 'I believe that this canvas . . . is one of the paintings in which
I best expressed the conception I then had of painting'), where

Luigi Russolo *Memories of a Night* 1911 oil on canvas 39¾ × 39⅜ in.
(101 × 100 cm.)
Collection Miss Barbara Jane Slifka, New York

the muffled figures tilt away to either side, does succeed in giving the spectator some sensation of being in the middle of a dispersing crowd and of blurred and fleeting images of hurrying figures.

It is perhaps curious that the Futurist painters did not immediately try to depict the very clear and vivid images which they had described in the Technical Manifesto, which would surely have presented no more problems than the vaguers ensations which they did attempt. Russolo, the least gifted as a painter, was the first of the group to use precise images from the manifesto in his work. His *Memories of a Night* (painted early in 1911) is certainly a remarkably ungainly picture, but it does seem to be the first real attempt to put the ideas of the Technical Manifesto into practice: images are superimposed on one another, and Russolo uses the 'psychological perspective' advocated by Soffici (an idea which he derived from the writings of Bergson). As a work of art it leaves much to be desired, but it was a far more daring conception than anything the Futurist painters had produced so far, and opened the way to the painting of 'states of mind' which proved to be one of the most fruitful of the Futurist themes.

The idea of the 'painting of states of mind' is largely influenced by the philosophy of Bergson, and particularly his concept of perception and 'psychic duration'. In *Matter and Memory* he wrote: 'There is no perception which is not full of memories. With the immediate and present data of our senses we mingle a thousand details out of our past experience.' The Futurists' dynamic view of the universe was also derived from the writings of Bergson who, in opposition to the idea that change is constituted by a series of changing states (which he called 'cinematographic'), held that true change 'can only be explained by true duration; it involves an interpenetration of past and present, not a mathematical succession of static states' (Bertrand Russell, *History of Western Philosophy*, 1945). Bergson also wrote 'Does not the fiction of an isolated object imply a kind of absurdity, since this object borrows its physical properties from the relations which it maintains with all others, and owes each of its determinations, and consequently its very existence, to the place which it occupies in the universe as a whole?' (*Matter and Memory*, 1910), an idea with which the Futurist painters were much occupied a little later. In May 1911 Boccioni explained his ideas of the painting of states of mind in a lecture at the Circolo Artistico in Rome.

Umberto Boccioni *States of Mind: the goodbyes* 1911 (1st version) oil on canvas 28½ × 37¾ in. (72·4 × 95·9 cm.)
Galleria d'Arte Moderna, Milan

'PURE SENSATION' he said, was its aim; the artist should strive for 'the acutest synthesis of all the senses in a *unique universal* one which will enable us to go back through our millenary complexity to primordial simplicity.' He was already working on the first version of his famous triptych called *States of Mind*: *the goodbyes; those who go; those who stay*, in which, using almost abstract, expressionist forms he vividly suggests the various collective emotions and sensations of a railway station: the sense of urgency and confusion, of reluctant separation; the sensation of speed, of objects flashing past, of confusing reflections; and finally, in the simplest and most effective of the three

38

Umberto Boccioni *States of Mind: those who go* (1st version) 1911 oil on canvas 28½ × 35½ in. (72·4 × 90·2 cm.) Galleria d'Arte Moderna, Milan

paintings, the sense of sudden loneliness, of flatness and anti-climax in those left behind, who trail off by themselves, isolated figures, no longer bound together by the excitement of departure.

Working on his own, away from the ferment of Futurism in Italy, Severini's early Futurist works show none of the uncertainty and clumsiness of the Milanese painters. Infinitely more decorative than theirs, his pictures demonstrate a more detached, objective and light-hearted interpretation of the Technical Manifesto. His *The Boulevard* (c. 1910) cannot be taken as a serious attempt to convey the 'rhythms of modern life'; it is a pretty and ingenious exercise in pattern-making in which 'light

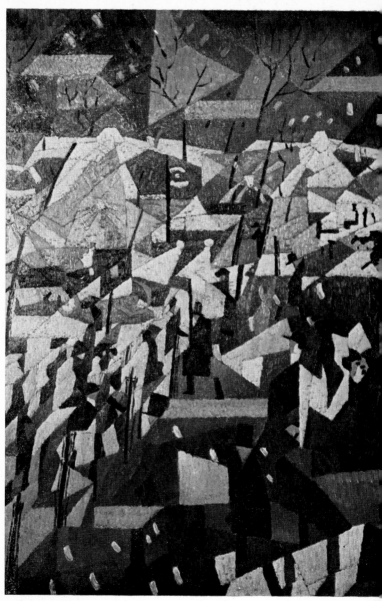

Gino Severini *The Boulevard* 1910 oil on canvas $28\frac{5}{8} \times 36\frac{1}{4}$ in.
(72·7 × 92·1 cm.)
Grosvenor Gallery, London

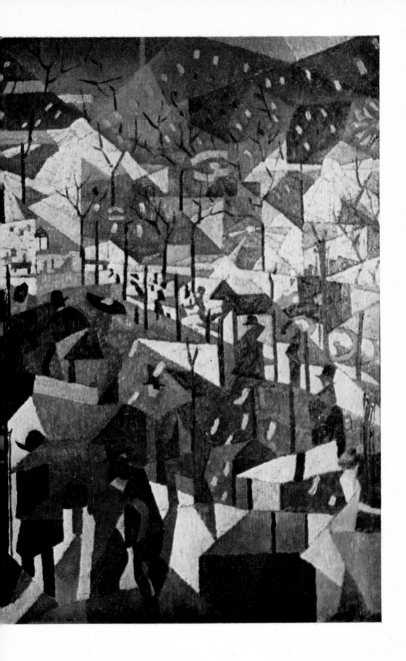

Umberto Boccioni *States of Mind*: *those who stay* (1st version) 1911 oil on canvas 28⅛ × 37¾ in. (72·4 × 95·9 cm.) Galleria d'Arte Moderna, Milan

and shadow cut up the bustle of the boulevard into geometrical shapes' (description provided by the painters in the catalogue to the Sackville Gallery exhibition in London, 1912), and it has only the most tenuous connection with the far more ambitious and passionate, and correspondingly less successful, 'Unanimist' paintings of Boccioni and Carrà. Severini was able to make use of Cubist devices in *The Boulevard*, and in *The Modiste* of the

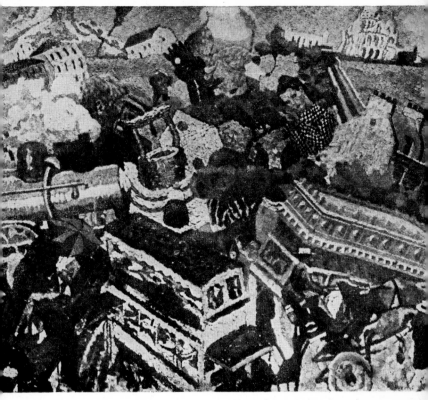

Gino Severini *Memories of a Journey* 1910–11 (whereabouts unknown)

same date, but he seems only to be interested in their decorative possibilities. In the more complex 'state of mind' painting *Memories of a Journey*, he does not employ them. This painting illustrates a more Futurist theme: the recollections of a journey from Italy to Paris, 'alluding thereby to the shrinkage of the globe as a result of modern transport which was one of Marinetti's favourite metaphors' (Marianne Martin, *Futurist Art and Theory,*

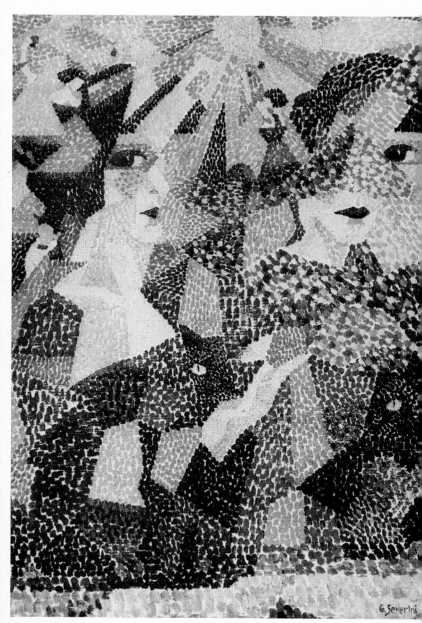

G. Severini

Gino Severini *The Obsessive Dancer* 1911 oil on canvas 28¾ × 21⅝ in.
(73 × 54·9 cm.)
Collection Mr and Mrs Samuel R. Kurzman, New York

Umberto Boccioni *The Street Enters the House* 1911 oil on canvas
39½ × 39½ in. (100·3 × 100·3 cm.)
Niedersächsische Landesgalerie, Hanover

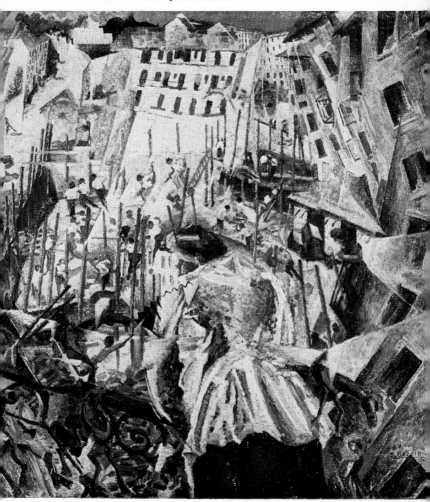

1968). Images from his home town and from Paris and things glimpsed and remembered on the journey are jumbled together, 'the proportions and values being rendered in accordance with the emotion and the mentality of the painter'. Severini's approach is more detached and intellectual than that of Boccioni or Russolo to similar subjects; forms drive into one another and curve, to convey the sensation of swaying and jolting, but there is no distortion of form for the purpose of expressing emotion. Severini's more formal, less expressive treatment of the painting of states of mind can also be seen in *The Black Cat,* illustrating 'the sense of morbid oppression after reading Edgar Poe's tale' and *The Obsessive Dancer,* in which he uses a skilful combination of Cubist and Neo-Impressionist techniques.

In their earliest Futurist works the Milanese painters had been concerned primarily with the expression of emotion of one sort or another which led them (and particularly Boccioni) to the development of a style tending towards abstract expressionism. In the summer of 1911, however, a change began to take place. Broadly speaking the paintings of this date show a greater interest in describing physical sensations and less in the expression of generalized but still conventional emotion. In *Street-pavers* (not a subject with any great emotive content) Boccioni seeks to convey nothing beyond the sight and perhaps the sound of the rhythmical blows of the pick-axe. He is similarly concerned with the representation of a physical sensation, though a more complex one, in *The Street Enters the House*; here figures scurry up and down the scaffolding of half-finished buildings, but without any of the sentimental exaltation of the forces of labour expressed in *The City Rises*; the bustle and movement, noise and colour of the street below flood past the figure at the window to envelop the spectator. Carrà's *The Jolts of a Cab* ('The double impression produced by the jolts of an old cab upon those inside it and those outside') illustrates the same tendency, although Carrà's works had always been more down to earth than those of Boccioni. Russolo again broke new ground by being the first to represent that truly Futurist object, a machine at speed; hitherto the most romantic and philosophical of the group, in *Speeding Train* he tries in an objective way to record the 'synthesis of the ridge of light produced by an express train going sixty miles an hour', anticipating Balla's later and more sophisticated renderings of similar themes such as *Plasticity of Lights + Speed.*

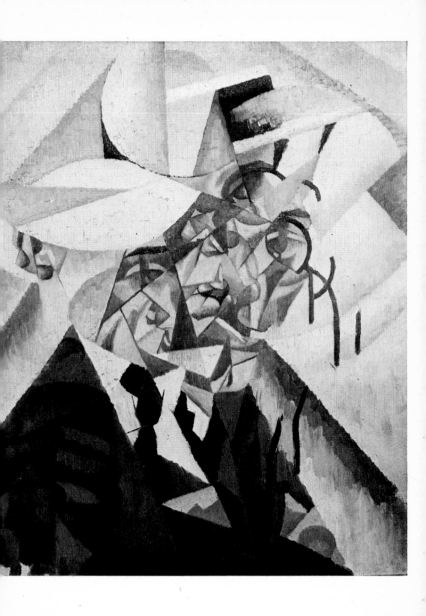

Gino Severini *Self-portrait* 1912 oil on canvas 21⅝ × 18⅛ in. (54·9 × 46 cm.)
Collection Dr Giuseppe Sprovieri, Rome

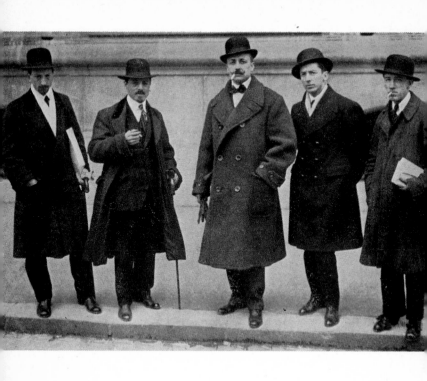

Photograph of Russolo, Carrà, Marinetti, Boccioni and Severini in Paris 1912

This change to a more objective or more 'scientific' type of painting apparently coincides with the painters' first acquaintance with Cubist theories. Their knowledge of Cubism at this stage was entirely second-hand, and came chiefly from Soffici's article on Picasso and Braque published in *La Voce* at the end of August. Its effect is seen most clearly in Boccioni's works, and his use of the device of telescoping together different views of a building by breaking up their vertical continuity (in *Study of a Woman among Houses* and *The Street Enters the House*) seems to indicate that he had seen a reproduction of one of Delaunay's *Eiffel Tower* series. It seems likely that they also received descriptions of Cubist experiments from Severini. He at any rate was responsible for bringing about the actual confrontation of Futurism and Cubism, a confrontation which radically altered the course of Futurist painting. He visited Milan in the late summer of 1911, and was so dismayed when he saw their work and heard that they were proposing to exhibit it in Paris in a couple of months' time, that he begged them to come and see for themselves 'where things stood . . . in art'. Feeling, no doubt, apprehensive at their coming exposure to the sophisticated Parisian gaze, and chastened by Severini's criticism (in a way that they were not inclined to be by Soffici's), Boccioni and Carrà, and possibly Russolo as well, financed by Marinetti, paid a short visit to Paris in mid-October.

Shown round by Severini, who had the *entrée* into Cubist circles, they saw a good deal while they were there, and its effect was to send them rushing back to Milan eager to put the new lessons into practice. The impact which direct contact with Cubism had on the Milanese painters can be seen at its best in the second version of Boccioni's *States of Mind* triptych, painted immediately after his return from Paris. In public, however, they displayed their usual extravagant boastfulness and were reluctant to admit that the Cubists had anything to teach them. The defiant attitude of the Futurist painters to Cubism and the new ideas which they developed from it are expressed in the preface to the catalogue of the exhibition of their work at the Bernheim–Jeune Gallery in Paris in February 1912. With absurd arrogance they claimed, 'What we have attempted and accomplished, while attracting around us a large number of plagiarists without talent, has placed us at the head of the European movement in painting . . .', although they had the grace to imply that they shared this position with 'the Post-Impressionists, Synthetists

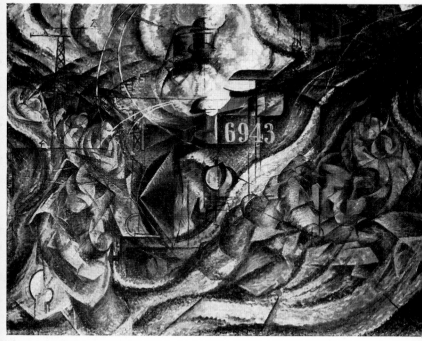

Umberto Boccioni *States of Mind: the goodbyes* (2nd version) 1911 oil on
canvas 27¾ × 37⅞ in. (70·5 × 96·2 cm.)
Private collection, New York

and 'Cubists of France, led by their masters Picasso, Braque,
Derain, Metzinger, Le Fauconnier, Gleizes, Léger, Lhote, etc.'.

They accused the Cubists of academicism and declared them-
selves to be 'absolutely opposed' to their art, chiefly because 'they
obstinately continue to paint objects motionless, frozen, and all
the static aspects of Nature'. The Futurists, on the other hand,
were going to 'seek for a style of movement' through the use of
'*force-lines*' :

All objects, in accordance with what the painter Boccioni
happily terms *physical transcendentalism,* tend to the infinite
by their *force-lines,* the continuity of which is measured by our
intuition ... We interpret nature by rendering these objects

Umberto Boccioni *States of Mind: those who go* (2nd version) 1911 oil on
canvas 27⅞ × 37¾ in. (70·8 × 95·9 cm.)
Private collection, New York

upon the canvas as the beginnings or the prolongations of the
rhythms impressed upon our sensibility by these very objects . . .
Every object reveals by its lines how it would resolve itself were
it to follow the tendencies of its forces. This decomposition is
not governed by exact laws but varies according to the character-
istic personality of the object and the emotions of the spectator.

These ideas were developed by Boccioni and Carrà in their
paintings of the next two years. Of the two, Carrà was the more
obviously affected by Cubism, and his *Rhythms of Objects* reflects
the attraction which the stability of Cubist construction had for
him. But at the same time he did not lose sight of Futurist aims,
and *The Galleria in Milan,* despite its density of Cubist forms and

Umberto Boccioni *States of Mind: those who stay* (2nd version) 1911 oil on canvas $27\frac{7}{8} \times 37\frac{3}{4}$ in. (70·8 × 95·9 cm.)
Private collection, New York

Giacomo Balla *Boccioni's Fist—Lines of Force* 1915 cardboard and wood painted red 33 × 31 × $12\frac{1}{2}$ in. (88·8 × 78·7 × 31·8 cm.)
Collection Mrs Barnett Malbin (Lydia and Harry Lewis Winston Collection), Birmingham, Mich.

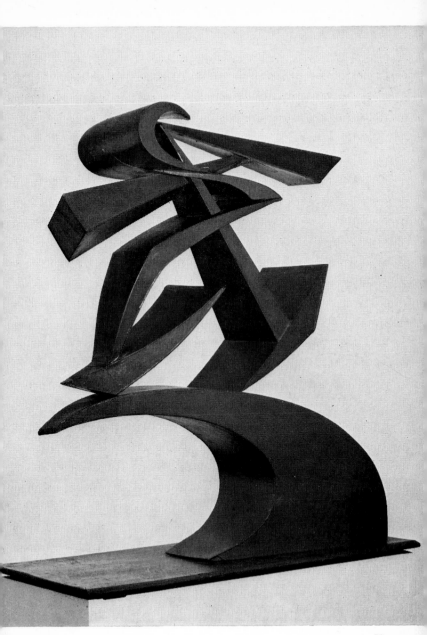

53

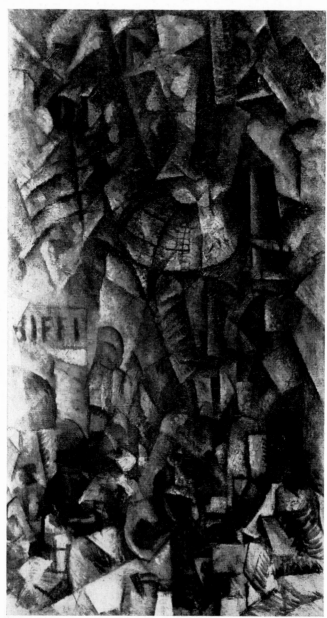

54

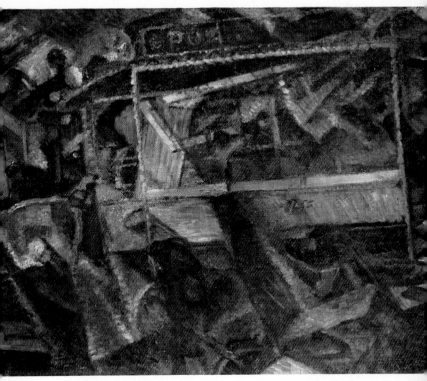

Carlo Carrà *What the Streetcar Said to Me* 1911 oil on canvas 21⅝ × 25½ in.
(55 × 65 cm.)
Collection Dr Giuseppe Bergamini, Milan

Carlo Carrà *The Galleria in Milan* 1912 oil on canvas 35¾ × 20¼ in.
◀ (91 × 51·5 cm.)
Collection Dr Gianni Mattioli, Milan

architectonic structure, continues the attempt which he made in
The Jolts of a Cab and *What the Streetcar Said to Me* to convey
the clatter and restless movement of the city. 'We Futurists', he
wrote, 'strive with the force of intuition to insert ourselves into
the midst of things in such a fashion that our "self" forms a single
complex with their identities', and these paintings seem also to
illustrate the passage in the Bernheim–Jeune catalogue which
describes the 'chaos and clashing of rhythms, totally opposed to
one another, which we nevertheless assemble into a new
harmony'. *Simultaneity (woman on a balcony)*, one of his finest

pictures, represents the culmination of Carrà's search for a balance between the solidity and order of Cubism and Futurist dynamism.

Boccioni's huge painting *Materia* (*Matter*) shows a similar increase in architectonic solidity, but the austerity and stability of Cubism were less suited to Boccioni's restless, emotional temperament, and this painting might almost be seen as a representation of the conflict between Cubism and Futurism. The massive, immobile figure of Boccioni's mother seems to remain impervious to the clamorous assaults of the dynamic material world; the impression of her bulk is unimpaired by the lines of force which penetrate her form. The series of paintings *Elasticity*,

Carlo Carrà *Rhythms of Objects c.* 1912 oil on canvas 20¼ × 26 in.
(51·1 × 66 cm.)
Collection Dr Emilio Jesi, Milan

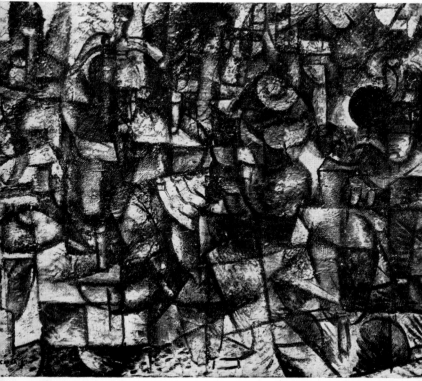

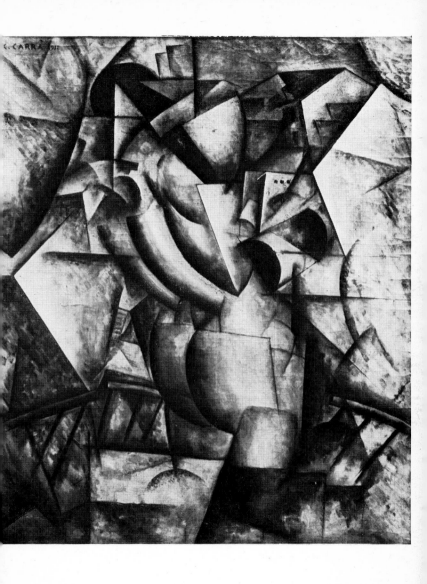

Carlo Carrà *Simultaneity—woman on a balcony* 1913 oil on canvas
57⅜ × 52⅜ in. (145·7 × 133 cm.)
Collection Dr Riccardo Jucker, Milan

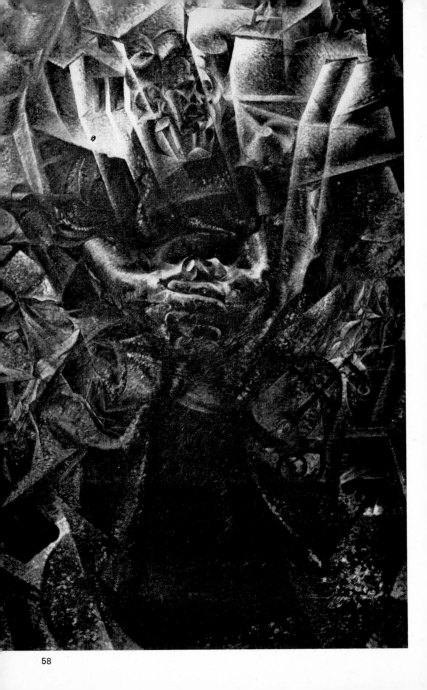

Dynamism of a Footballer and *Dynamism of a Cyclist* demonstrates
Boccioni's search for a way of expressing 'that new absolute:
velocity, which the truly modern temperament cannot disregard'.
In achieving this his forms, like Carrà's, become increasingly
abstract, but they are concerned always with the fluid, muscular
movements of the human body, and so the abstract forms he uses
are not the geometrical Cubist ones that Carrà adopts for his
portrayal of the more mechanical movement that interested him.
When Carrà describes the violent motion of man and animal in
Horse and Rider (*speed decomposes the horse*) the result,
though attractive, looks distinctly clockwork in comparison.

◀ Umberto Boccioni *Materia* (*Matter*) 1912 oil on canvas 88¼ × 59¾ in.
(225 × 150 cm.)
Collection Dr Gianni Mattioli, Milan

Umberto Boccioni study for *Dynamism of a Cyclist* 1913 pen and ink
6 × 9½ in. (15·2 × 22·9 cm.)
Galleria d'Arte Moderna, Milan

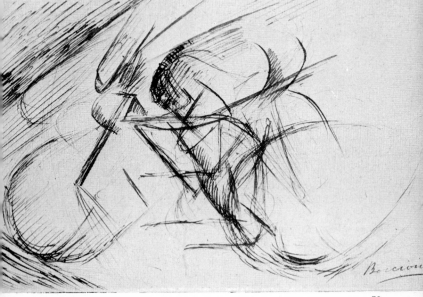

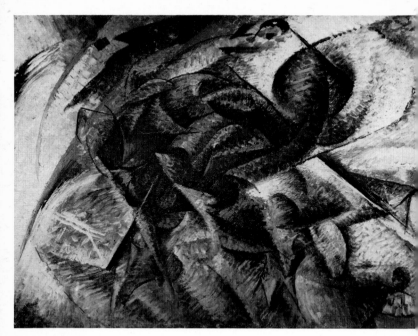

Umberto Boccioni *Dynamism of a Cyclist* 1913 oil on canvas $27\frac{1}{2}$ × $37\frac{3}{8}$ in.
(70 × 95 cm.)
Collection Dr Gianni Mattioli, Milan

Russolo remained almost entirely unaffected by the impact of
Cubism. In *Plastic Synthesis of the Movements of a Woman* and
The Solidity of Fog he develops his own interpretation of the
rhythms of the moving figure and its expansion and absorption
into the surrounding atmosphere, giving space the same plastic
value as matter, as the others were doing, but without relying on
Cubist forms. He was, however, becoming more and more
involved with his experiments with music, and in 1913 gave up
painting to occupy himself with the 'Art of Noises', in which he
saw greater possibilities for reflecting the Futurist universe.

Giacomo Balla, on the other hand, who had remained aloof
from the other painters for so long, now began to come into his

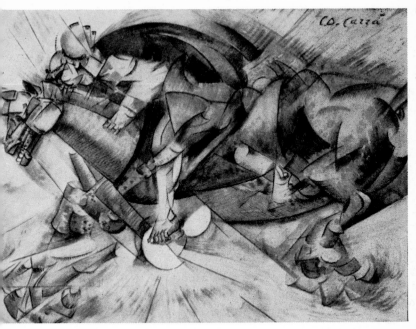

Carlo Carrà *Horse and Rider* (*speed decomposes the horse*) 1912 ink and watercolour $10\frac{1}{4} \times 14\frac{1}{4}$ in. (26 × 36·2 cm.)
Collection Dr Riccardo Jucker, Milan

own. He was older than the others, with a family to support, and it was less easy for him to throw himself into Futurist activity as whole-heartedly as they did. Once he had begun to experiment with Futurist themes, however, he developed rapidly. Free from the distraction of the Futurist movement as a whole, and not involved, like the Milanese painters, with propaganda and the elaboration of theories, Balla was able from the first to concentrate on purely visual problems, and did not suffer from the confusion of ideas which side-tracked his colleagues. Starting from an analytical study of movement in his *Leash in Motion* and *Rhythm of a Violinist* in 1912, he combined this with effects of light and colour in *Girl Running on a Balcony* to produce an almost

Photograph of Luigi Russolo
From 'The Art of Noises' manifesto

Luigi Russolo *Plastic Synthesis of the Movements of a Woman* 1912 oil on
canvas $33\frac{1}{2} \times 25\frac{1}{2}$ in. (85 × 65 cm.)
Musée des Beaux-Arts, Grenoble

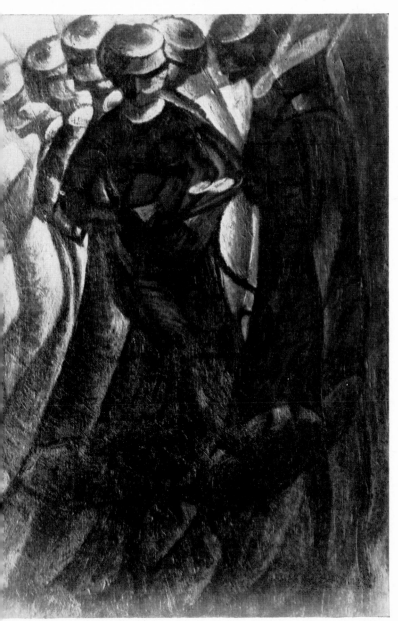

Luigi Russolo *The Houses Continue into the Sky* 1913 oil on canvas
39½ × 39½ in. (100 × 100 cm.)
Kunstmuseum, Basle

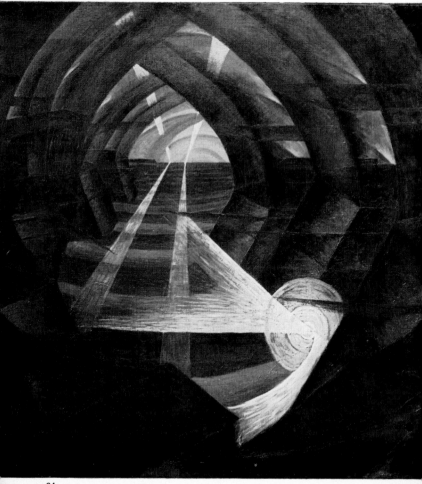

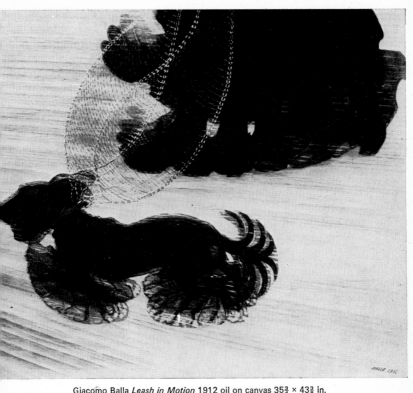

Giacomo Balla *Leash in Motion* 1912 oil on canvas 35¾ × 43⅜ in.
(90·8 × 110·2 cm.)
Collection A.Conger Goodyear, New York

abstract pattern which does not rely on the multiple images of
the figure to convey its movement. His study of objects in motion
went hand in hand with a quasi-scientific investigation of the
construction of light in a series of abstract works which he called
Iridescent Interpenetrations. His representations of movement
become more complex in the numerous paintings analysing the
flight of swifts, such as *Swifts: paths of movement + dynamic
sequences.* He devoted the same careful investigation to the
more specifically Futurist theme of speeding motor-cars, to
produce remarkable diagrammatic expressions of velocity such as
Abstract Speed—wake of a speeding automobile and *Speed of
an Automobile + Lights + Noise.*

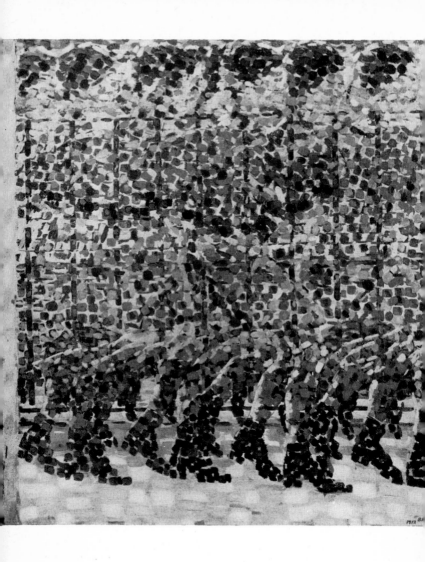

Giacomo Balla *Girl Running on a Balcony* 1912 oil on canvas 49¼ × 49¼ in.
(125·1 × 125·1 cm.)
Galleria d'Arte Moderna, Milan. Grassi Collection

In their greater concentration on purely artistic matters and their avoidance of the literary and didactic which frequently damaged the work of the Milanese painters, there is a strong similarity between Balla and Severini. Both were more detached and so more light-hearted. Writing to his family and enclosing an example of one of his 'iridescent interpenetrations', Balla says: 'First of all enjoy a moment this bit of iridescence because I am more than certain it will please you; this result is the product of an infinity of trials and retrials to discover finally in its simplicity the ends of delight.' The sense of delight, so markedly absent from the works of Boccioni or Carrà, is also evident in Severini's

Giacomo Balla *Swifts: paths of movement + dynamic sequences* 1913 oil on canvas 38½ × 47¼ in. (67·3 × 125·1 cm.) Museum of Modern Art, New York

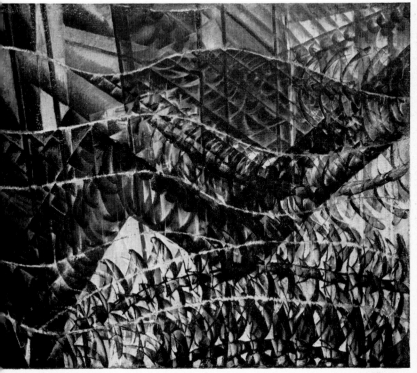

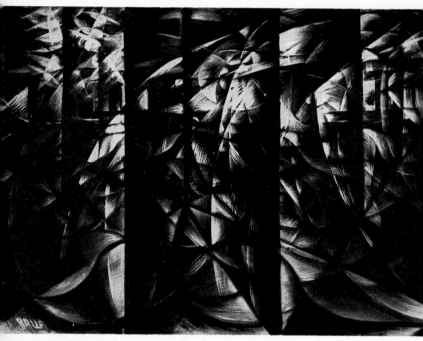

Giacomo Balla *Speed of an Automobile + Lights + Noise* 1913 oil on canvas
$34\frac{1}{4} \times 51\frac{1}{8}$ in. (87 × 130 cm.)
Kunsthaus, Zürich

Giacomo Balla *Iridescent Interpenetration No. 1* 1912 $39\frac{3}{8} \times 23\frac{5}{8}$ in.
(100 × 60 cm.)
Collection Mrs Barnett Malbin (Lydia and Harry Lewis Winston Collection),
Birmingham, Mich.

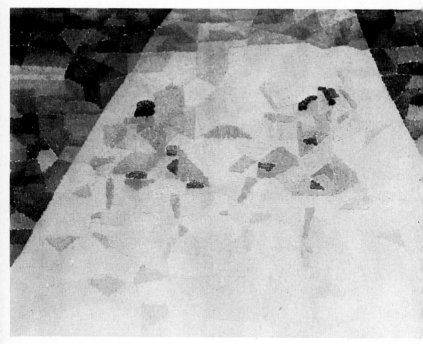

Gino Severini *The Yellow Dancers* 1911 oil on canvas 18 × 24 in.
(45·7 × 61 cm.)
Fogg Art Museum, Harvard University, Cambridge, Mass. Gift of Mr and
Mrs Joseph H. Hazen

Gino Severini *White Dancer* oil on canvas 23⅝ × 17¾ in. (59·4 × 45·1 cm.)
Collection Dr Riccardo Jucker, Milan

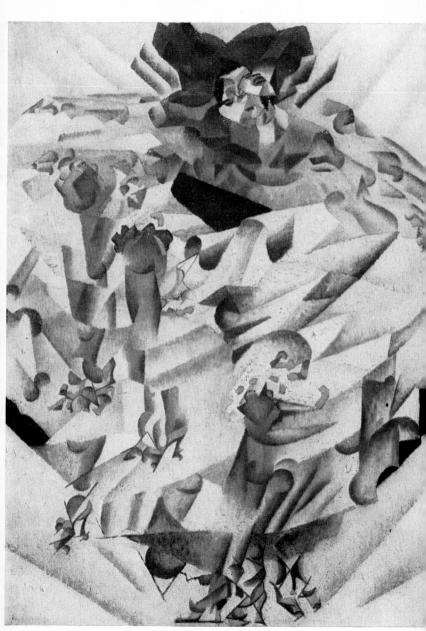

71

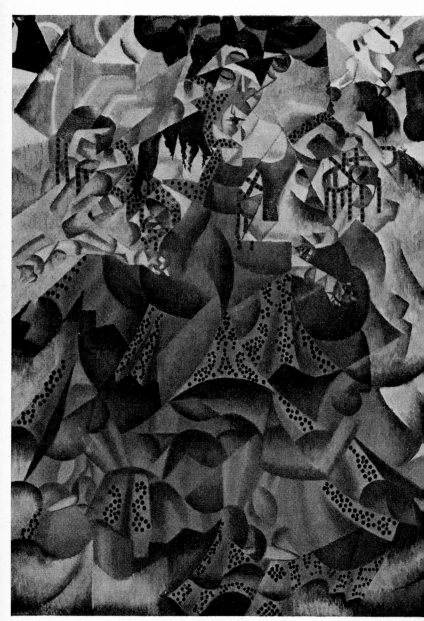

paintings of this period. With a few exceptions (such as *Nord-Sud Métro* or *Autobus*) the side of city life which Severini chose to paint was not the noise and confusion of city streets, nor rioting masses nor the forces of labour, however heroic, but the gaiety of the café and the night-club; he preferred the graceful movements of the night-club dancer to the uncomfortable jerks of a tram. Like Balla also, he showed a far greater interest in the depicting of colour and light for its own sake. His series of *Dancers* conveys the sensation of rhythmic movement as much by the breaking up and contrast of light and colour as by the fragmenting of forms; 'lines of force' are used with greater delicacy and decorative effect than in Boccioni's pictures. Severini began increasingly to evoke the movement of the dance by form and colour alone. 'It has been my aim', he wrote, 'while remaining within the domain of the plastic, to realize . . . forms which partake more and more of the abstract.' By 1913 this had become 'an overpowering need for abstraction', which drove him 'to put on one side all realization of mass and of form in the sense of pictorial relief . . .' and led him 'in the direction of synthesis and the absolute'. 'I consider the Plastic Absolute to be the communion, the sympathy, which exists between ourselves and the centre of things themselves', he wrote, revealing the influence of Marinetti's theory of analogy on which his poetical reforms were based. From this Severini developed the concept of the 'plastic analogies of dynamism' illustrated in such works as *Sea = Dancer + Vase of Flowers* and *Dancer = Sea*. The first of these illustrates what Severini described as 'apparent analogies': 'The plastic expression of the sea, which in real analogy provokes in me a dancer at the first glance, as apparent analogy gives me a vision of a great vase of flowers. These apparent analogies . . . help to intensify the expressive value of the plastic work.' The second work is based on the simpler form of 'real analogy'. His painting *The Spherical Expansion of Light* takes these abstract images of universal dynamism to the final stage, where no links to the world of objects remain: 'we wish to enclose the universe

Gino Severini *Blue Dancer* 1912 oil on canvas with sequins $24\frac{1}{8} \times 18\frac{1}{4}$ in. ($61 \cdot 3 \times 46 \cdot 4$ cm.)
Collection Dr Gianni Mattioli, Milan

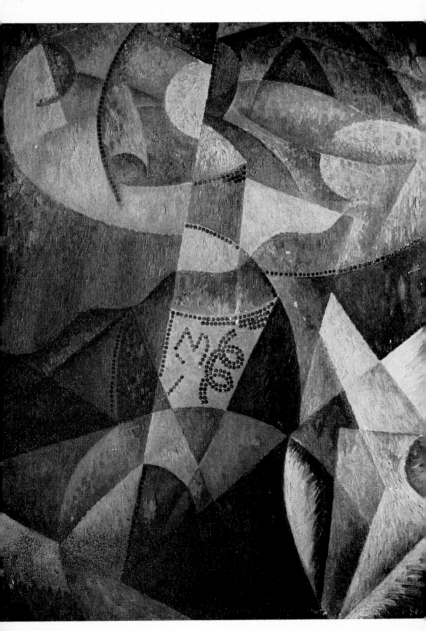

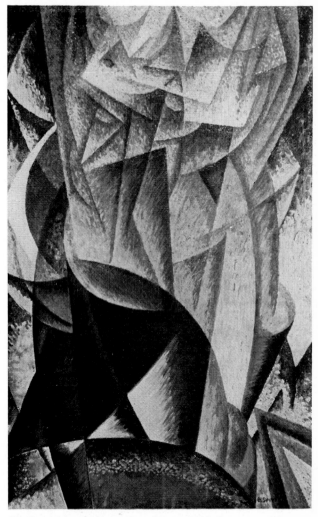

Gino Severini *Sea = Dancer + Vase of Flowers* 1914 oil on canvas with aluminium 36¼ × 23⅝ in. (92·1 × 60 cm.)
Collection Mr and Mrs Herbert M. Rothschild, New York

◀ Gino Severini *Dancer = Sea* 1913 oil on canvas with sequins 36½ × 28¾ in. (92·7 × 72·1 cm.)
Collection Mrs Barnett Malbin (Lydia and Harry Lewis Winston Collection), Birmingham, Mich.

in a work of art. Objects no longer exist'; it represents light as an abstract force expanding in space, rather as Boccioni's *Dynamism of a Cyclist* represents the expansion of muscular energy in space. This work marks the culmination of Severini's Futurist style. He produced a series of Futurist war paintings after this, urged by Marinetti, but for him the artistic possibilities of Futurism were exhausted, and he turned soon afterwards to Cubism.

The activity of the Futurist artists was at its height in 1913. By this time their paintings had been seen all over Europe. The Futurist exhibition (in which only Balla was not represented) which opened in Paris in February 1912 went on to London, Berlin, Brussels, The Hague, Amsterdam and Munich. The following year Severini had one-man shows in London and Berlin, and Boccioni in Paris and Rome, while the Futurists showed as a group (including Balla) in Rome, Rotterdam, Berlin and Florence. Their work was arousing interest in America as well as Europe, and they were invited to take part in the great Armory Show in New York. Having established themselves and created a considerable stir in the art world, and having in their various ways absorbed the lessons of Cubism, the Futurists set out to conquer new fields, urged on to fresh efforts by Marinetti who felt that as soon as the movement ceased to produce new and revolutionary ideas it would be moribund. In 1913 Marinetti published a more revolutionary version of his Technical Manifesto of Literature; Russolo produced his manifesto 'The Art of Noises', perhaps the most original and startling contribution to Futurism to date, and Carrà, not to be outdone, wrote a manifesto on 'The Painting of Sounds, Noises and Smells', in which—reacting against the sobering effect of Cubism—he declared, in the onomatopoeic language advocated by Marinetti, that:

THE PAINTING OF SOUNDS, NOISES AND SMELLS DENIES . . . greys, browns . . . the pure horizontal, the pure vertical . . . the right angle . . . the *cube* . . . and WANTS Reds, Reeeds that screeeeeeam . . . greeeeeens that shrieeeek . . . the dynamic arabesque . . . The sphere, the whirling ellipse . . . the spiral and all the dynamic forms which the . . . artist's genius can discover [and that the artist must become] a vortex of sensations, a pictorial force, and not a cold, logical intellect

One of the most important of these new departures was Boccioni's into the field of sculpture. He published his Manifesto

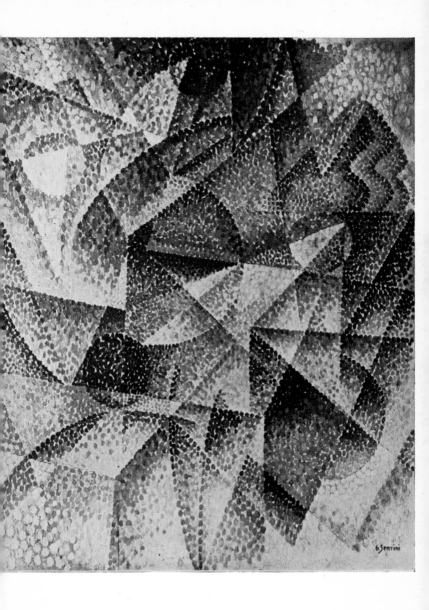

Gino Severini *The Spherical Expansion of Light* 1912 oil on canvas
23⅝ × 19¾ in. (60 × 50 cm.)
Private collection, Paris

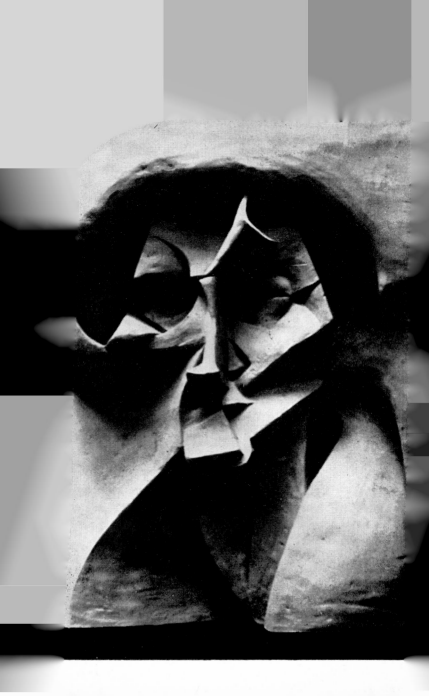

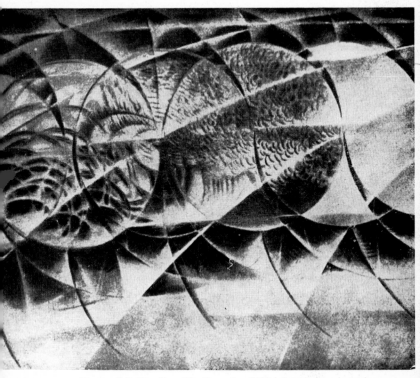

Giacomo Balla *Densities of the Atmosphere* 1913 (whereabouts unknown)

◀ Umberto Boccioni *Abstract Voids and Solids of a Head* 1912 or early 1913 (destroyed)

Dalla rete di rumori: - RISVEGLIO DI UNA CITTÀ.

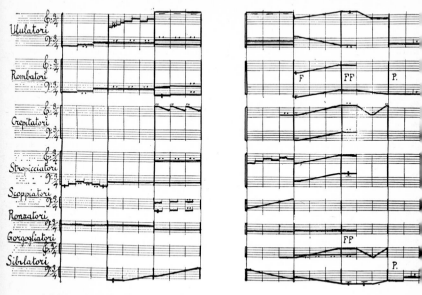

Luigi Russolo *Noise Music: awakening of a city*
From *Lacerba* 1 March 1914. The instruments named are : howlers, boomers,
cracklers, scrapers, exploders, buzzers, gurglers and whistles.

of Futurist Sculpture in April 1912, before he had actually tried
his hand at the new medium, and made his debut as a sculptor
in Paris, at the Galerie La Boëtie in June the following year. Of
the eleven pieces shown at this exhibition, only four remain.
Boccioni's interest in sculpture grew out of his attempts in such
paintings as *Materia* to find a more monumental way of represent-
ing the interplay between the inner life of the object and the
dynamism of its environment, and the essential oneness of these
two elements. It was also inspired by the ambition he expressed
to 'surpass' the Cubists, and he holds the distinction of being the
first to translate Cubist ideas, combined with those of Futurism,
into sculpture.

Medardo Rosso had rendered atmosphere implicitly, by showing
how it dissolved the static outlines of form. Boccioni went a stage

further and proposed to 'Break open the figure and enclose the environment in it', ensuring 'the absolute and complete abolition of the finite line and closed sculpture'. The titles of his earliest attempts, *Fusion of a Head and a Window* and *Head + House + Light,* which are known only from old photographs, explain what Boccioni was trying to do, and also indicate his failure to integrate these different elements into a new aesthetic whole. In the sculpture manifesto Boccioni maintained that 'even twenty different materials can compete in a single work to effect plastic emotion . . . glass, wood, cardboard, iron, cement, horsehair, leather, cloth, mirrors, electric lights, etc.' and that:

> a Futurist composition in sculpture will embody the marvellous mathematical and geometrical elements that make up the objects of our time. And these objects will not be placed next to the statue as explanatory attributes or dislocated decorative elements, but, following the laws of a new conception of harmony, will be embedded in the muscular lines of the body. Thus from the shoulder of a mechanic may protrude the wheel of a machine, and the line of a table might cut into the head of a person reading; and a book with its fan-like leaves might intersect the stomach of the reader.

These pieces fairly bristle with the 'architectural elements of the SCULPTURAL ENVIRONMENT in which the subject lives' recommended in the manifesto, and with 'real' materials such as bits of iron railing and a bun of real hair. The materials used in *Head + House + Light* are simpler than those of *Fusion of a Head and a Window*, and it is more successful as a sculptural entity, but still the elements of the environment are not happily integrated with the long-suffering figure beneath them. Instead of merging with it, the interior life of the object seems to be hemmed in by its environment. This is not true of the bronze *Development of a Bottle in Space,* and it was in this traditional medium, despite his insistence on the use of unconventional materials, that Boccioni's finest sculpture was produced. In their preface to the Bernheim–Jeune catalogue the Futurists had written that 'Each object reveals by its lines how it would be decomposed according to the tendencies of its forces' and this bronze illustrates, though in an ordered and rather uncharacteristically objective way, 'the emotional architecture of the object's plastic forces'.

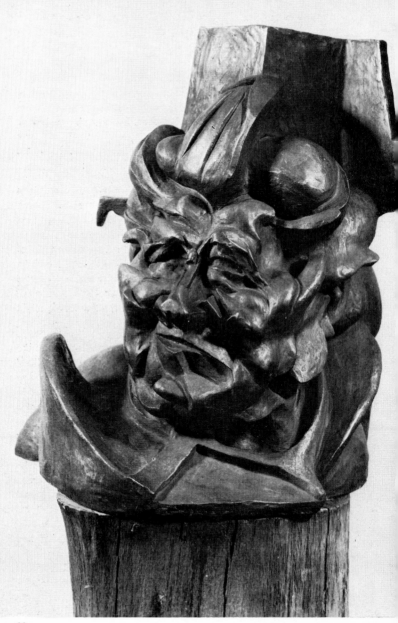

Umberto Boccioni *Antigraziosa* (*Anti-graceful*) 1912 bronze 24 in. (61 cm.) h.
Collection Mrs Barnett Malbin (Lydia and Harry Lewis Winston Collection),
Birmingham, Mich.

Umberto Boccioni *Fusion of a Head and a Window* 1912 various materials
(destroyed)

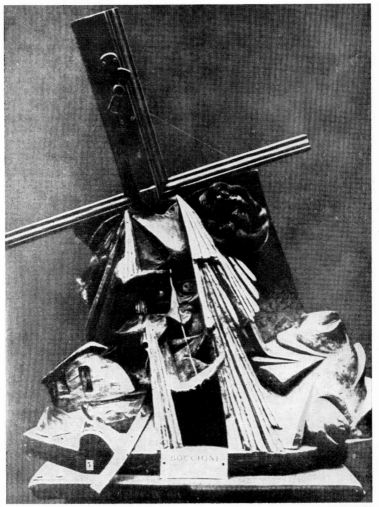

Umberto Boccioni *Head + House + Light* 1912 various materials (destroyed)

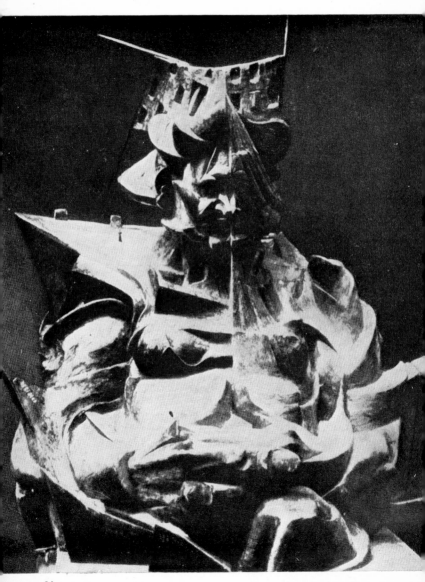

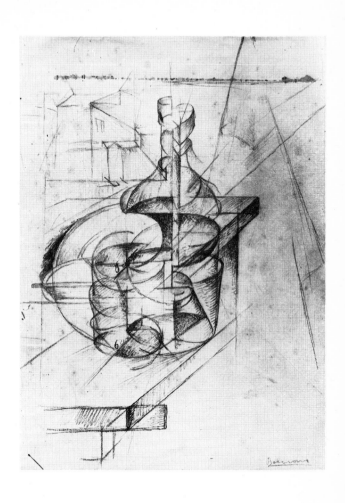

Umberto Boccioni *Table + Bottle + Houses* 1912 pencil drawing 13⅛ × 9½ in.
(33 × 24·1 cm.)
Galleria d'Arte Moderna, Milan

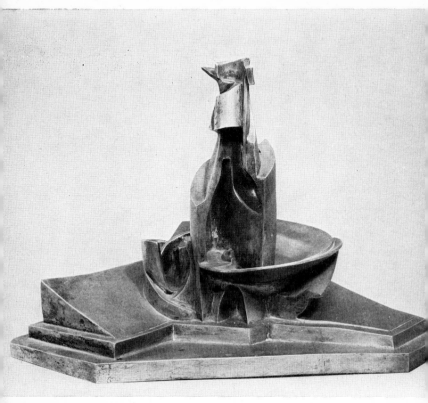

Umberto Boccioni *Development of a Bottle in Space* 1912 silvered bronze
15 × 12⅞ × 23¾ in. (38·1 × 32·7 × 60·3 cm.)
Museum of Modern Art, New York

Umberto Boccioni *Synthesis of Human Dynamism* 1912 (destroyed)

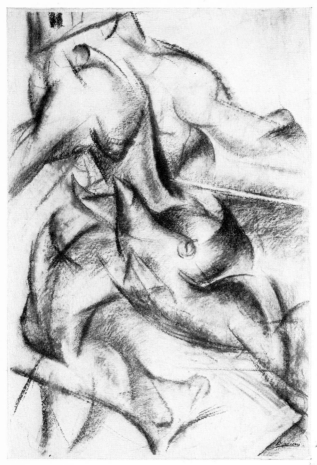

Umberto Boccioni *Muscular Dynamism* 1913 charcoal 34 × 23¼ in.
(86·4 × 59·1 cm.)
Museum of Modern Art, New York

Umberto Boccioni *Unique Forms of Continuity in Space* 1913 bronze 43½ in.
(110·5 cm.) h.
Collection Mrs Barnett Malbin (Lydia and Harry Lewis Winston Collection),
Birmingham, Mich.

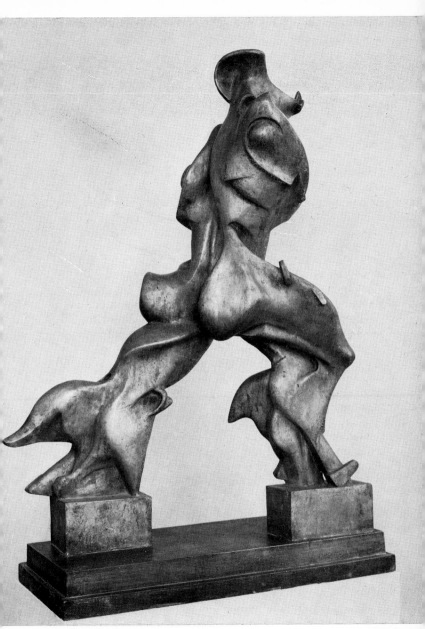

Although in the sculpture manifesto Boccioni seems to have anticipated some of the directions which sculpture would take in the next fifty years, he was not yet ready for them himself, and his own masterpiece in sculpture, the heroic bronze figure called *Unique Forms of Continuity in Space,* is more the culmination of the tradition of the free-standing statue than the start of something new. In the manifesto he had written 'the straight line will predominate', symbolizing 'the severity of steel that determines the lines of modern machinery', but in this work, and in *Muscoli in Velocita (Speeding Muscles)* and *Spiral Expansion of Muscles in Motion* (both lost) which led up to it, he is concerned with representing the human body in motion, and the fluid forms are more suggestive of flying drapery than of machinery. He had realized that 'the problem of dynamism in sculpture does not depend . . . only on the diversity of materials but principally on the interpretation of form'. After completing this piece, Boccioni gave up sculpture and returned to painting.

'There is no fear more stupid', Boccioni declared in his sculpture manifesto, 'than that which makes us afraid to go beyond the bounds of the art we are practising. There is no such thing as painting, sculpture, music or poetry; there is only creation.' This idea was echoed in Carrà's concept of 'total art' explained in his frenzied manifesto on 'The Painting of Sounds, Noises and Smells'. He apparently found this idea difficult to realize in practice, however, and it developed into an adaptation of Synthetic Cubism, with which he and Soffici experimented in such works as *Circular Synthesis Of Objects* (Carrà) and *Watermelon, Fruit Dish, Bottle* (Soffici). Although Carrà would sometimes react passionately against 'classicism', Cubism in fact had an irresistible pull for him. In his 'free-word' painting *Patriotic Celebration,* 'the plastic abstraction of civil strife', however, the Futurist spirit is triumphant. Severini had been the first to use the technique of free-word painting, in such compositions as *The Snake Dance* (reproduced in *Lacerba,* 1 July 1914), but it lent itself well to the purposes of political agitation which absorbed

Carlo Carrà *Patriotic Celebration* free-word painting 1914 papier collé
15⅛ × 11¾ in. (38·7 × 29·8 cm.)
Collection Dr Gianni Mattioli, Milan

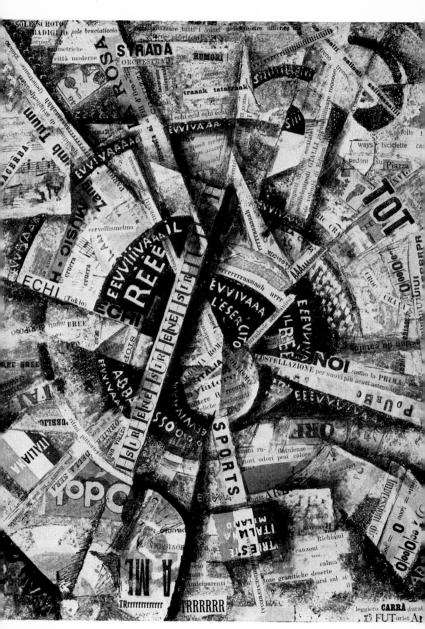

91

Carlo Carrà *Pursuit* 1914 collage and gouache on paper on canvas
15¾ × 26¾ in. (39 × 68 cm.)
Collection Dr Gianni Mattioli, Milan

the energies of the Futurists in 1914, and its propaganda possi-
bilities were almost immediately exploited to support the Futurists'
anti-Austrian rallies and interventionist demonstrations in the
months of frenzied political excitement between the outbreak of
the war and Italy's intervention in it.

The Futurists were determined to take full advantage of 'the

immense artistic novelties' presented by the war. Carrà published his *Guerrapittura* in March 1915, which besides a number of essays, contained free-word compositions, drawings and collages inspired by the war. Urged by Marinetti to interest himself 'pictorially in the war and in its repercussions in Paris' and to 'try to live the war pictorially, studying it in all its marvellous

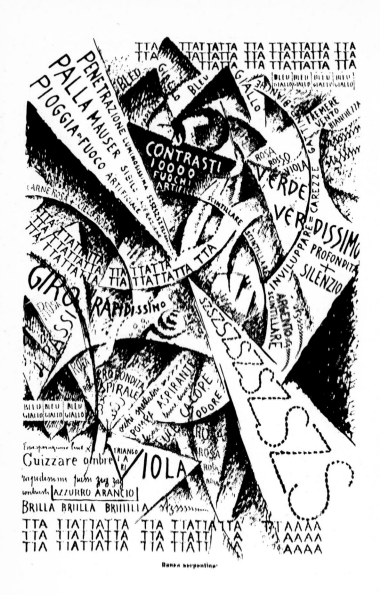

Gino Severini *The Snake Dance*
From *Lacerba* 1 July 1914

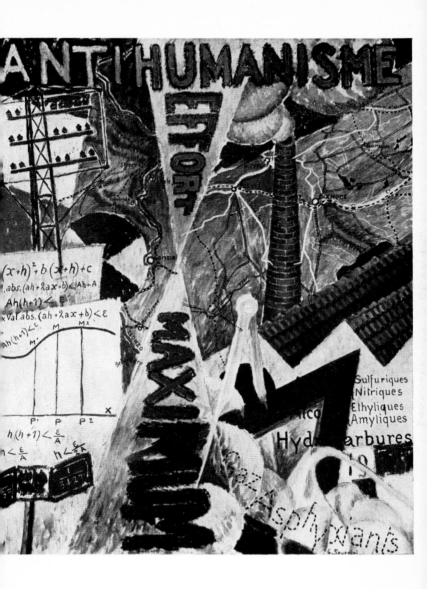

Gino Severini *War* 1914–15 oil on canvas $36\frac{1}{4} \times 28\frac{3}{4}$ in. (92 × 73 cm.)
Private collection, Milan

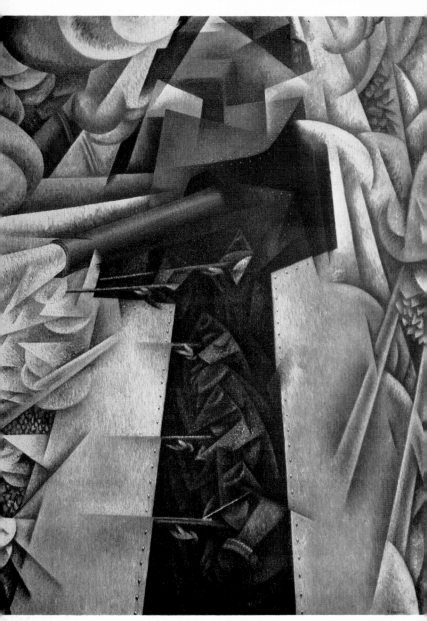

Gino Severini *Armoured Train* 1915 oil on canvas 46 × 34½ in.
(116·8 × 87·6 cm.)
Collection Mr Richard S. Zeisler, New York

Giacomo Balla *Flag on the Altar of the Fatherland* 1915 oil on canvas
39½ × 39½ in. (100·3 × 100·3 cm.)
Collection Donna Benedetta Marinetti, Rome

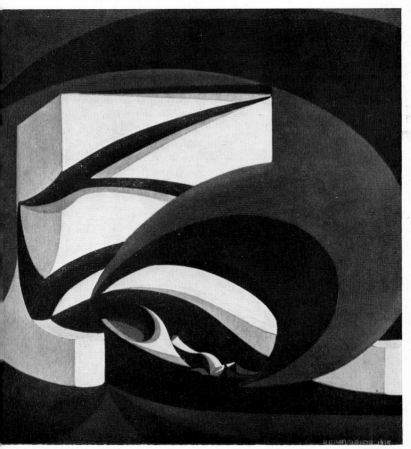

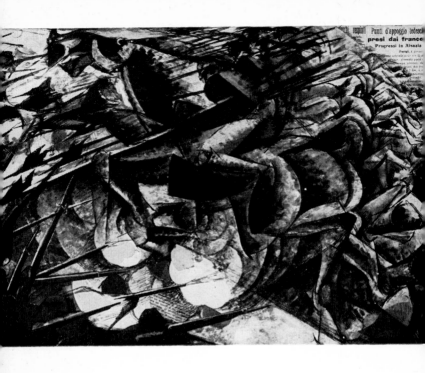

Umberto Boccioni *Cavalry Charge* 1914 tempera and collage on cardboard
$12\frac{7}{8} \times 19\frac{1}{2}$ in. (32·7 × 49·5 cm.)
Collection Dr Riccardo Jucker, Milan

mechanical forms . . .', Severini produced a series of war paintings such as *War* and *Armoured Train* in which he tried to express the idea of war '. . . by a plastic ensemble composed of these realities : cannon, factory, flag, mobilization order, aeroplane, anchor . . . because these realities are symbols of general ideas'. Balla responded to the war mood with swirling abstract patterns of bright colours, as in his *Flag on the Altar of the Fatherland,* which anticipate the 'hard-edged' painting of the 1950s. Boccioni, though the most active in political demonstrations, seems to have produced no war pictures except the papier collé *Cavalry Charge.*

The common commitment of the Futurists to the war tended to disguise the fact that the movement had already begun to disintegrate. In the first few years its members had worked together closely with a fruitful exchange of ideas, pooling their intellectual resources and using their energies to further the cause of Futurism, which had something of the quality of a religion. As they grew more mature, so their different temperaments and artistic tendencies became more marked. They began to feel the need of developing individually, and to vie with one another in the production of new ideas, which, according to Severini, 'came out without being known to the others as if each feared being robbed or outdone by another', as previously they had vied collectively with Cubism ; jealousies and misunderstandings began to disrupt the group. In addition to this they were exhausted by the intense and passionate activity of the past few years and in need of a little solitude and peace and quiet. In a letter of 1916 to the Futurist musician Pratella, Boccioni wrote : 'The burden of having to elaborate in oneself a century of painting is terrible. So much more so when one sees the new arrivals to Futurism grasping the ideas, mounting them and running at break-neck speed', and in fact, by 1914 he was beginning to turn to a style based on that of Cézanne. Papini and Soffici having joined the group in 1913 and put their review *Lacerba* at the service of Futurism, soon found themselves disapproving of some of its more extravagant notions. It was not long before they were chafing at Marinetti's dominance of the movement and trying to drive a wedge between true Futurism and 'Marinettism'.

Architecture

Perhaps the most notable addition to Futurist theory before
Italy's entry into the Great War in May 1915 was in the field of
architecture. Antonio Sant'Elia was the movement's only
architect, and he died before he had actually built anything, but
he left behind him the Manifesto of Futurist Architecture, contain-
ing ideas which were to have an important influence on twentieth-
century architecture, and a collection of drawings which anticipate
in a remarkable way the architecture of the twenties and thirties.

In 1914, when he was twenty-six, Sant'Elia exhibited in Milan
with the Nuove Tendenze group (of which he was a founder), a
group of drawings under the title of *The New City*. In the catalogue
of the exhibition he published a 'Messaggio sul Architettura', on
which, with some additions from Marinetti, the Manifesto of
Futurist Architecture was based.

Marinetti and the Futurists had long regretted the lack of a
representative of their views in architecture, the 'mother of the
plastic arts', and when Carrà told him about Sant'Elia's work
Marinetti was eager to recruit him for the movement: 'There are
a great many people in Milan and in all Italy awaiting our ideas
on architecture', he wrote in a letter to Soffici. But, although his
outlook was fundamentally Futurist, Sant'Elia was reluctant to
join the movement, being anxious, according to Carrà, to
preserve his 'freedom of action'. However, Carrà introduced him
to Marinetti and he seems to have been won over at least suffi-
ciently to allow his 'Messaggio' to be transformed into the
Manifesto of Futurist Architecture.

The idea of the New City, designed to serve the needs of modern
industrial society, was naturally dear to the Futurists' hearts.
Their championship of it so far had been, however, a negative
one. They kept up a series of vigorous attacks against the
passéist cities of Italy: Rome, Florence and Venice were described
as 'the three festering sores of our peninsular'. In July 1910 the
Futurists threw down 800,000 leaflets containing their manifesto
'Against *passéist* Venice' from the clock tower in the Piazza San
Marco, advocating the demolition of decaying palaces and the
filling in of the evil-smelling canals and the rebuilding of Venice
as a modern city with highways and factories. The great industrial

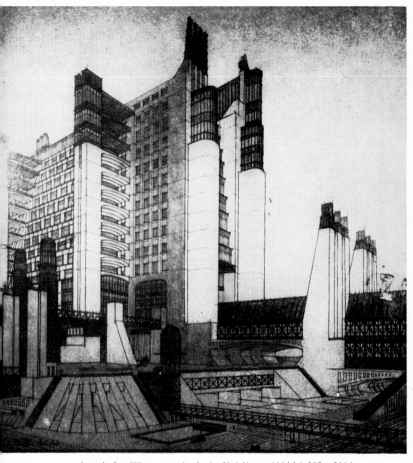

Antonio Sant'Elia, perspective for La Città Nuova 1914 ink $20\frac{7}{8} \times 20\frac{1}{2}$ in. (53 × 52·1 cm.)
Museo Civico, Como

cities of Turin and Milan and Genoa were alone considered to do honour to Italy.

Sant'Elia's 'Messaggio' echoed these Futurist ideas: 'We must invent and re-build our modern city *ex novo*, like an immense and tumultuous shipyard, active, mobile and everywhere dynamic.' The imaginative drawings made by Sant'Elia between 1912 and

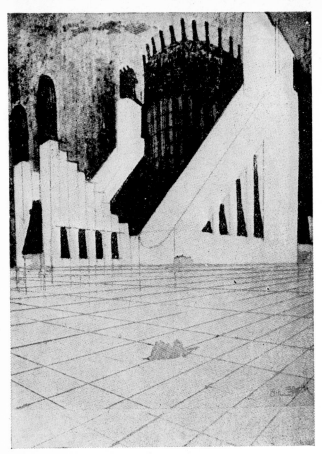

Antonio Sant'Elia, design for a theatre, pen and ink $10\frac{5}{8} \times 8\frac{1}{4}$ in.
(27 × 21 cm.)
Museo Civico, Como

1914 range from the barest sketches of dynamic shapes, to the detailed projects of the city of the future shown at the New Tendencies exhibition. The conception of these latter seems to have originated with the proposal to rebuild Milan Station, and they illustrate many points made in the 'Messaggio'. The new architecture must take advantage of 'every benefit of science and technology' and be governed by 'the special conditions of modern living'.

Antonio Sant'Elia, study for a monumental building (church or factory?)
1912–14 pen and ink $10\frac{5}{8} \times 7\frac{1}{2}$ in. (27 × 19 cm.)
Museo Civico, Como

Calculations of the resistance of materials, the use of reinforced concrete and iron exclude 'Architecture' as understood in the Classical and traditional sense. Modern structural materials and our scientific concepts absolutely do not lend themselves to the disciplines of the historical styles, and are the chief cause of the grotesque aspect of modish constructions where we see the lightness and proud slenderness of girders, the slightness of reinforced concrete bent to the heavy curve of the arch, aping the solidity of marble . . .

He condemned the use of applied decoration: the beauty of the modern building would lie only in 'the inherent beauty of its lines and its plastic relief'. 'Decoration', he wrote, 'considered as something superimposed on architectural forms, is an absurdity. Whatever decorative value our art possesses must come from the

103

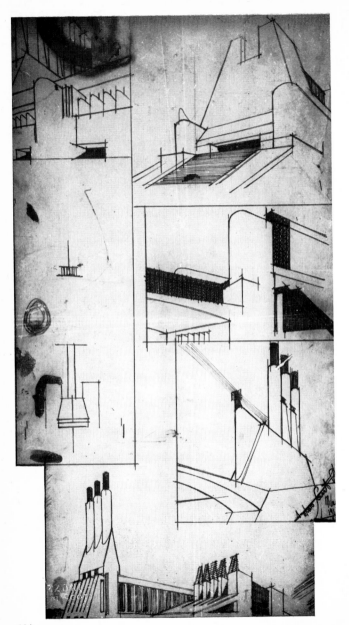

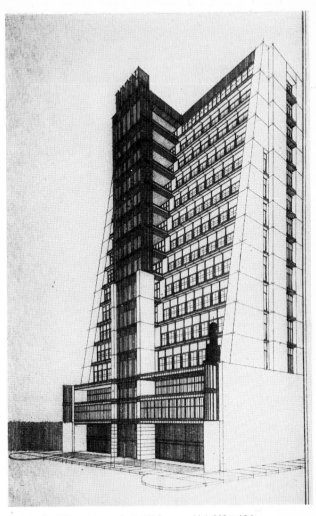

Antonio Sant'Elia *casa a gradinata* 1914 pen and ink 26¾ × 13 in.
(67×33 cm.)
Museo Civico, Como

Antonio Sant'Elia, sheet of studies 1912–14 pen and ink
Museo Civico, Como

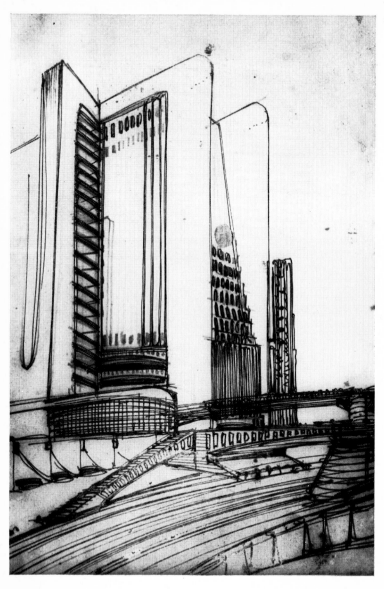

Antonio Sant'Elia, design for block with external lifts on 3 street levels 1914
pen and ink $10\frac{1}{2} \times 8\frac{1}{4}$ in. (26·7 × 21 cm.)
Museo Civico, Como

use and arrangement of the material in its original and untouched condition. The only exception permitted is the violent and uniform colouring of the surfaces.' Anticipating Le Corbusier, he declared that the modern house must be 'like a gigantic machine'. Some of his most elaborate drawings are for tall blocks of flats, each storey stepped back from the one below in a way that later became common practice in city building. They had external lifts, because 'lifts must no longer hide away in the stairwells, but the stairs—now useless—must be abolished, and the lifts must swarm up the façades like serpents of glass and iron'. His drawings are as much town-planning projects as architecture, and show familiarity with the latest ideas on the subject. His New City would be organized round a complex network of roads and communication systems on several levels; streets would 'plunge storeys deep into the earth, gathering up the traffic of the metropolis, connected for necessary transfers to metal cat-walks and high-speed conveyor belts'. His buildings would be designed to accommodate neon skyline advertising, and would be placed back to back with space in between for transport and services.

Marinetti wrote with ecstatic admiration of the splendour of power-stations, and this was also the theme of some of Sant'Elia's most powerful and imaginative drawings. The Manifesto of Futurist Architecture is largely a translation of these ideas into Marinetti's language, but it also contains some additions for which Sant'Elia was apparently not responsible. The most celebrated statement of the manifesto: 'THE HOUSES WILL LAST FOR LESS TIME THAN WE DO. EACH GENERATION WILL HAVE TO BUILD ITS OWN CITY' was almost certainly added by Marinetti, who wrote in *Le Futurisme* in 1911, 'We insist that a masterpiece must be burned with the corpse of its author . . . against the conception of the immortal and the imperishable we set up the art of the becoming, the perishable, the transitory, and the expendable.' Although Sant'Elia, according to Carrà, did not agree with this assertion, much of the manifesto's international reputation and influence were based on it. Another addition to the original 'Messaggio' maintained that 'architecture must be understood as the power freely and boldly to harmonize environment and man, that is to render the world of things a projection of the world of the spirit . . .'. Finally, Sant'Elia himself held that although the city of the future would be 'extraordinarily brutish in its mechanical simplicity', architecture is not 'an arid

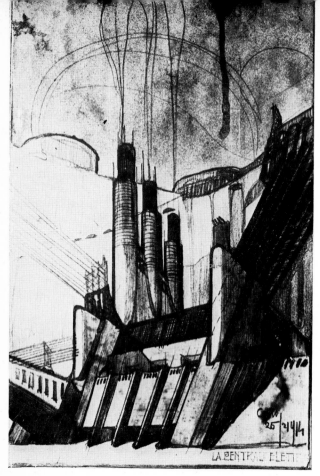

Antonio Sant'Elia, design for power station 1914 ink, pencil and watercolour
11¾ × 7⅞ in. (29·8 × 20 cm.)
Collection Avv. Paride Accetti, Milan

combination of practicality and utility, but remains art, that is synthesis and expression'.

Almost all of Sant'Elia's projects are presented in perspective drawings and very few in plan, and none of them was ever carried out. Together with Marinetti, Boccioni and Russolo, he joined a battalion of volunteer cyclists in July 1915, and was killed in action the following October. Thanks to Marinetti, Sant'Elia's work was published later in *De Stijl* and *Der Sturm*, and it was largely due to Marinetti's efforts that Sant'Elia's reputation was established outside Italy.

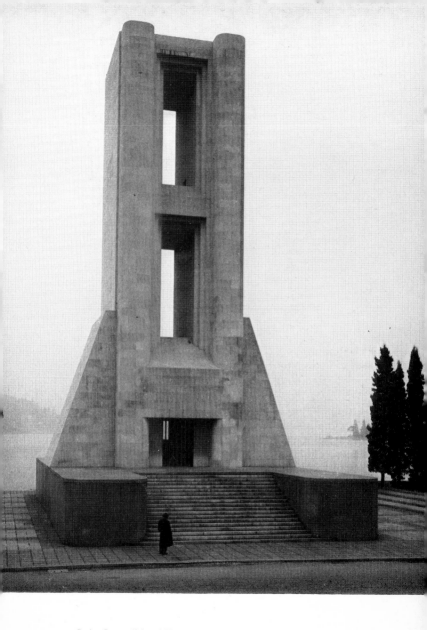

Enrico Prampolini and Giuseppe Terragni *Monument to the Fallen* completed
early 1930s, based on designs by Sant'Elia
Como

Carlo Carrà *parole in libertà* (free-word composition)
Lacerba 1 July 1914

Literature

As we have seen, Futurism began as a literary movement, and Futurist art relied very largely on the ideas with which Marinetti was all the while experimenting in his writings. It seems to be universally agreed that Marinetti was not a good poet. It was not through the example of his works that Futurism played an important part in the development of literature, but through his ideas, through the general feeling of energy and vitality that he spread about him, through his insistence on constant change and renewal and his championship of new ideas.

Marinetti's literary theories began with the insistence on the use of up-to-date subject matter. '. . . the primitive and the savage, the sylvan and the rustic ; . . . the adoration of the gloomy, the mouldy, the filthy, and decrepit ; . . . the exaltation of decay, disease, failure and suicide' were henceforth to be abandoned as a source of literary inspiration in favour of subjects drawn from the great, mechanical, noisy, dynamic modern world. In Marinetti's *Le Futurisme,* D'Annunzio is attacked for having 'refined from all his talent the four intellectual poisons that we must destroy at all costs' :

1 The sickly nostalgic poetry of distance and memory. 2 Romantic sentimentalism streaming with moonlight, rising towards the Woman-Beauty, ideal and fatal. 3 Obsession with lust and its eternal triangle of adultery seasoned with the pepper of incest and the stimulating spice of Christian sin. 4 The profound passion for the past. . . .

Like the painters, the Futurist poets sought to convey the 'simultaneity' of impressions which characterized modern life. The stylistic devices by which they sought to achieve this aim were the abolition of traditional syntax, metre and punctuation and the introduction of mathematical and musical symbols, onomatopoeia and 'free expressive orthography . . . freely deforming, remodelling the words by cutting or lengthening them . . . enlarging or diminishing the number of vowels and consonants'. The communication of 'lyrical intoxication' was to be aided by making use of the expressive and pictorial possibilities of typography, which was to prove one of the most imitated of their innovations. In a 'Declaration to the Printer' in *Lacerba* (1 May

AL BUFFET DELLA STAZIONE

Il legno del tavolino diagonale in partenza con l'aria e i binari verso i nordi natali delle foreste de' miti diurni

Il lutto di tutte le notti vedove frizionate di profumi e nenie abbandonate nel deserti dal sole tenore d'affrica e d'arabia isterie in carovana di violetto indaco al mostro sangue nervi cervello

di POETA di

EUROPA mostro allucinat

O

da
un
rag-
gio
in
festa
fuoco
bianco
di porcel-
lana
sguar-
do
es-
ti-
vo
gei-
she
d'a-
mo-
re
nostalgia di buddismi
lazzaroni

NAUFRAGO
RONISMO
in una gocci
CAFFÈ

O

25

NELL'I-
DELLA cicca spenta
la di
centesimi
MA NE-
DI

LACRI-
RA

CICCA SPENTA

MALINCONIA

conto 5 storn

mentre la carne bruta marcisce ne' letti avelli col vermi de' poli nel sudore e di sonno intriso di vermi de' poli nel sudore e le teste sul ritmo delle locomotive sognate nell'incoscienza elementare rombanti di di sastri a' tunnelli a' fiumi di spaventi internazionali sotto i culi del buio domestico fetore fisico metafisico dietro le persiane scale viranti del sole del giorno inutile inu-

Partenza

Addio

BYRRH BYRRH

ECLA

BYRRH ECLA

'AURORA

CHININA-MIGONE ECLA

ECLA

ITALA

CHININA-MIGONE

rossi rossi arancio gialli freschi rossi freschi senza stelle
né uccelli né ombre gli bangrars dell'alba verginità bu-
cato di buoliche schiaffeggiate d'affiches

da treni d'amanti fuggilaschi

gli bui
Non vai
compagni-
bbrivi-

CARA NON
LA TUA SALUDUUTE stantuffuffuffuffuffi PARIGI O
RIFIORIRA crivellando gli orizzonti di vetriolo
dento ne' sibili di fumo nell'as-
ASSEREMO
musica desti

Gino Severini *Sea = Dancer*
Lacerba 15 April 1914

1914) Papini called the printer the writer's closest confidant and
friend. The use of different types—italic, roman or gothic—in
different sizes and colours 'welded painting to poetry just as
onomatopoeia had welded lyricism to music'. Letters had their
own intrinsic beauty, and by using them imaginatively the printed
page could itself be transformed into a work of art. When he was

F.T.Marinetti, frontispiece to *Zang Tumb Tumb* 1912

accused of imitating the poetic devices of Mallarmé, Marinetti replied:

> This new array of type, this variety of colours, this original use of characters enable me to increase many times the expressive power of words. By this practice I combat the decorative and 'precious' style of Mallarmé, his *recherché* language. I also combat Mallarmé's static ideal. My reformed typesetting allows me to treat words like torpedoes and to hurl them forth at all speeds: at the velocity of stars, clouds, aeroplanes, trains, waves, explosives, molecules, atoms.

The essence of poetry, the Futurists considered, was analogy. Marinetti's *parole in libertà* or 'free words' with which he supplanted *vers libre* were to facilitate instantaneous, telegraphic communication. Nouns were to be used alone, without adjectives or verbs, linked to each other in a 'chain of analogies'. Marinetti claimed that his ideas for a new poetry were inspired by his experiences in the trenches when he went to observe the fighting in Tripoli and in the Balkans in 1911 and 1912, and they were elaborated in his Technical Manifesto of Futurist Literature in 1912 and in the later version of this called 'Wireless Imagination and Words in Liberty' (1913).

> The man who has witnessed an explosion does not stop to connect his sentences grammatically. He hurls at his listeners shrieks and substantives. Let us imitate his example! This release from grammatical subserviency will also enable the artist to do what no one, so far, has succeeded in doing: to communicate by words the sensations of weight and the power of diffusion by which he can express odours. It is a new field which is opened to asyntactical writers.

Noise (which, together with speed, the Futurists saw as the most characteristic feature of modern life), must be introduced into poetry by every means possible, and Futurist recitations were accompanied by lively sound effects, both real and onomatopoeic.

According to Marinetti and his followers, human psychology as a subject for literature was exhausted. Futurist writing was to concern itself instead with 'the attractions not of men, but of metals—their alloys, fusions and combinations; to discover new sources of passion in the dramas of the chemical laboratory or the tragedy of the blast furnaces'. 'We wish in literature to express the

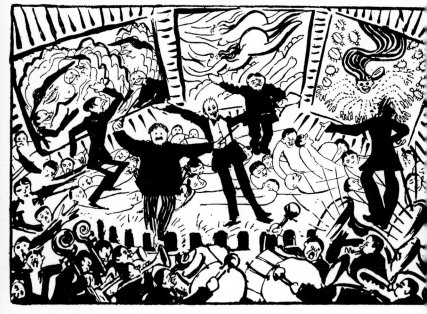

Umberto Boccioni caricature of a Futurist evening in Milan
From *Uno, due, e . . . tre* 17 June 1911

life of the motor, the new wild animal whose general instincts we shall comprehend when we have got to know the instincts of the diverse forces which compose it.' And a new superman 'mechanized . . . with replaceable parts' would evolve to take his place in this 'mechanical kingdom'.

Marinetti's body of writing is enormous and by all accounts very largely unreadable except for the manifestoes. Here his style is seen at its best, and found many imitators. He also wrote a large number of 'synthetic plays' in which action and dialogue are compressed to the minimum, and a 'Futurist novel', *Mafarka le Futuriste* (for which he spent two months in prison as the result of a successful prosecution for obscenity), which is described as a 'tedious rhetorical tale of rape and battle in a mythical Africa' (James Joll, *Intellectuals in Politics,* 1960).

Theatre

Marinetti's other great interest, apart from literature, was the theatre. The movement as a whole has a distinctly theatrical quality; its ideas, the language in which they are expressed, are themselves dramatic (hence a considerable part of their attraction); the Futurist painters and poets took to the stage to proclaim their doctrines, and these occasions were directed by Marinetti very much as theatrical entertainments, complete with staged brawls. The Futurists seemed to regard the amusement of the public as one of the functions of the artist; there was a good deal of deliberate buffoonery in their antics, and they never seemed to resent or be hurt by the laughter or mockery they aroused.

In Paris, before the launching of Futurism, Marinetti was associated with Lugné-Poë's *Théâtre de l'Œuvre,* where his first play, *Le Roi Bombance,* was produced in 1905. This *'tragédie satirique'* was modelled on Alfred Jarry's *Ubu Roi,* and Jarry's 'theatre of the absurd' formed the basis for Marinetti's later theatrical theories and indeed for much of the character of the Futurist movement as a whole.

The first Futurist manifesto concerned with the theatre was The Dramatists' Manifesto of October 1910, and was signed by Marinetti only. It was largely devoted to boosting the dramatists' morale in preparation for the coming battle. 'We Futurists', it read, 'teach authors above all contempt for the public.' For the rest it was somewhat vague, and stipulated only that Futurist drama should deal with 'some part of the Great Futurist dream . . . excited by the speeds on the earth, the sea and in the sky, and dominated by steam and electricity' and with the 'sensation of the power of the machine'.

It was not until 1913 that Marinetti had time to devote himself at length to the subject again, but in that year he wrote his manifesto 'The Variety Theatre', one of the most remarkable of Futurist documents, which set forth in some detail his ideas for the theatre, and rendered the previous manifesto obsolete. Futurist dramas were to be modelled on the music hall or variety theatre which, 'born in our time from Electricity, has fortunately no tradition, no masters, no dogmas . . .'. The possibilities open to the music hall were endless, and the Futurist 'theatre of shock and *fisicofollia*' would take advantage of them all. The music hall

Fortunato Depero, design for *Ballerina* Rome 1915

Gino Severini *The Waltz* 1912 gouache and pencil

Giacomo Balla, design for Diaghilev's Ballet Russe production of
Stravinsky's *Feux d'artifice* Rome 1917

could exploit all the inventions and mechanical contrivances of the
modern age ; it could use cinematography to produce 'incalculable
visions and unrealizable spectacles (battles, riots, motor-
racing . . .)'. Caricature, 'abysses of ridicule', hilarity, and 'profound
analogies between the human, animal, vegetable and mechanical
worlds' were among its marvellous elements. It was the only form
of theatre to 'make use of the collaboration of the public' which
'takes part uproariously in the action'. In addition to these
virtues, the variety theatre was a 'school of heroism' and the 'strong,
healthy atmosphere of danger' was created on its stage ; it
destroyed also 'the Solemn, the Sacred, the Serious, and the
Sublime in Art with a capital A'. The Futurists would take all this
and use it and go on to destroy any logic that might still lurk in
the spectacles of the variety theatre. When he arrives at the
point of describing how the Futurists will develop from this their
120

'teatro dello stupore' ('theatre of shock, or stupefaction') Marinetti is carried away into *parole in libertà* and onomatopoeia and it becomes difficult to follow him exactly, but one is left with the impression that the new theatre will bombard the senses with the noisiest, most tumultuous, most dazzling, most bewildering collection of simultaneous sensations that the imagination and considerable ingenuity of Marinetti and his followers can devise; an experience in short, which would drive the spectators (or participators as they would be) to the very brink of insanity.

The manifesto of 'The Futurist Synthetic Theatre' which followed 'The Variety Theatre' in 1915, signed by Marinetti, Emilio Settimelli and Bruno Corra, was a rather more sober document. The dramatic 'synthesis' which will take the place of the traditional play, will be 'AUTONOMOUS, ALOGICAL, UN-REAL'. Although elements drawn from reality will be used, they will be 'combined according to whim' and the synthesis will resemble nothing but itself. With 'colour, forms, sounds and noises' it will, like the works of Futurist painters and musicians, 'assault the nerves with violence'. The spectators will be made to 'forget the monotony of everyday life' through a 'labyrinth of sensations characterized by the most exasperated originality and combined in unexpected ways'. Anticipating the Surrealists, the Futurists declared that discoveries of the subconscious, and of 'ill-defined forces' must be brought to the stage. The entertainment would 'symphonize' the feelings of the public, exploring and revealing them by every possible means.

Several 'theatrical syntheses' by Marinetti and others (Boccioni also experimented with this medium) were performed just before and in the early years of the war, but it was the second generation of Futurists, centring round Balla, Prampolini, Depero, Bragaglia and others, who chiefly exploited and developed these ideas.

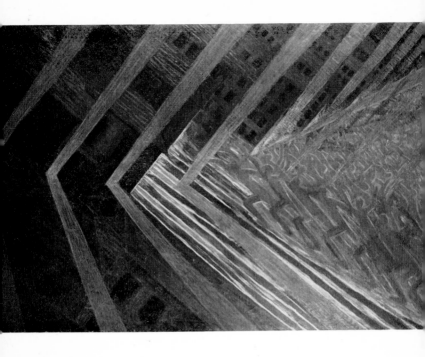

Luigi Russolo *The Revolt* 1911 oil on canvas 57 × 90$\frac{1}{2}$ in. (150 × 230 cm.)
Gemeentemuseum, The Hague

Futurism and politics

In 1924 Benedetto Croce wrote: 'For anyone who has a sense of historical connections, the ideological origins of Fascism can be found in Futurism, in the determination to go down into the streets, to impose their own opinions, to stop the mouths of those who disagree, not to fear riots or fights, in its eagerness to break with all traditions, in this exaltation of youth which was characteristic of Futurism . . .'

'If our paintings are futurist, it is because they are the result of absolutely futurist conceptions, ethical, aesthetic, political and social', wrote the Futurist painters in the preface to the Bernheim–Jeune catalogue in 1912. National pride and aggressiveness is evident in their attitude to Cubism, in particular, and the constant seeking after new ideas was largely due to their desire, as Italians, to outdo in originality the Cubists and leaders of the Parisian *avant-garde*. The painters also took an active part in the political activities organized by Marinetti. They took part in 'irredentist' demonstrations against Austria (Italians were still living under Austrian rule in the Trentino); and later were ardent 'interventionists', campaigning vigorously for Italy to enter the Great War.

Marinetti's first political manifesto was written for the general elections of 1909. 'We Futurists,' he wrote,

who have but one programme, the pride, the power and the expansion of the nation, denounce to the country the eternal shame of a possible Clerical victory. We Futurists call on all the young men of Italy to engage in a fight to the finish against those candidates who have come to terms with the old-timers and with the clergy. We Futurists demand a national representation which, freed from mummies and cowardly pacifists, shall be ready to thwart every plot and reply to every affront.

Boccioni echoes these feelings in his *Pittura scultura futurista* of 1914: 'We wish to give our country a conscience that will drive her steadily onward through unremitting toil, toward unrelenting conquest. We look forward to the day when Italians, no longer dozing over the glory of their ancestors, which is not their glory, will come to realize the joy of being themselves, armed,

123

Giacomo Balla 'The Anti-neutral Suit' manifesto 1914

nostalgica, romantica e rammollente. Noi vogliamo colorare l'Italia di audacia e di rischio futurista, dare finalmente agl'italiani degli abiti bellicosi e gioconda.

Gli abiti futuristi saranno dunque:

1. — **Aggressivi**, tali da moltiplicare il coraggio dei forti e da sconvolgere la sensibilità dei vili.

Vestito bianco - rosso - bleu
del parolibero futurista Cangiullo. *(Peruzzi.)*

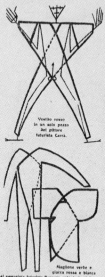

Vestito rosso
in un solo pezzo
del pittore
futurista Carrà.

Maglione verde e
giacca rossa e bianca
del rumorista futurista Russolo, volontario ciclista.

2. — **Agilizzanti**, cioè tali da sostentare la flessuosità del corpo e da favorire lo slancio nella lotta, nel passo di corsa e di carica.

3. — **Dinamici**, per disegno e colori dinamici delle stoffe (triangoli, coni spirali, ellissi ecc.) che ispirino l'amore del pericolo, della velocità e dell'assalto, l'odio della pace e della immobilità.

4. — **Semplici e comodi**, cioè facili a mettersi e a togliersi, che ben si prestino per poter tutte il forte, guadare i fiumi e lanciarsi a nuoto.

5. — **Igienici**, cioè tagliati in modo che ogni punto della pelle possa respirare nelle lunghe marcie e nelle salite faticose.

6. — **Gioiosi**. Stoffe di colori e iridescenze entusiasmanti. Impiegare i colori muscolari violentissimi, rossissimi, verdissimi, gialloni, arancionoooni, vermiglioni.

7. — **Illuminanti**. Stoffe fosforescenti che possono accendere la temerità in una assemblea di poltroni, spandere luce intorno quando piove, e correggere il grigiore del crepuscolo nelle vie e nei nervi.

8. — **Volitivi**. Disegni e colori violenti, imperiosi e imperanti come comandi sul campo di battaglia.

9. — **Asimmetrici**. Per esempio, l'estremità delle maniche e il davanti della giacca saranno a destra rotondi, a sinistra quadrati, dislinti contrastanti di linee.

10. — **Di breve durata**, per rinnovare incessantemente il godimento e l'animazione fervente del corpo.

11. — **Variabili**, per mezzo dei **modificanti** (applicazioni di stoffa, di ampiezza, spessori, disegni e colori diversi) da disporre quando si voglia e dove si voglia, su qualsiasi punto del vestito, mediante bottoni pneumatici. Ognuno può così inventare in ogni momento un nuovo vestito. Il modificante sarà prepotente, urtante, stonante, decisivo, guerresco, ecc.

Il cappello futurista sarà asimmetrico e di colori aggressivi e festosi. Le scarpe futuriste saranno dinamiche, diverse l'una dall'altra, per forma e per colore, atte a prendere allegramente a calci tutti i neutralisti.

Sarà brutalmente esclusa l'unione del giallo col nero.

Si pensa o si agisce come si veste. Poiché **la neutralità è la sintesi di tutti i**

Vestito bianco - rosso - verde
del pittore e scultore futurista Boccioni. *(Sera.)*

Giacomo Balla
pittore.

DIREZIONE DEL MOVIMENTO FUTURISTA
Corso Venezia, 61 - MILANO

up-to-date, and hostile to everybody. . . .' And Papini declared in 1913 that 'Futurism means frantic love for Italy and for her greatness; since childhood I have longed for Italian supremacy; . . . Futurism means Italy *tout court*—an Italy greater than the one we have known, more modern, more courageous, more progressive than other nations. The Futurists work for this great Italy of tomorrow.'

Marinetti's second political manifesto was written to celebrate the Italian conquest of Tripoli in 1911, 'this great Futurist hour of Italy'. This document again praises 'the love of danger, of violence, patriotism and war' and declares that 'the word Italy must overrule the word Freedom'. 'We are proud to feel that the war-like fervour which inspires the whole country equals our own, and we invite the Italian Government, which has finally become Futurist, to magnify all the nation's ambitions, to despise the stupid accusations of piracy, and to proclaim the birth of Pan-italianism.'

From 1903 to 1914 the Italian government was under the control of Giovanni Giolitti. It was a period of political and social pacification. By his skilful and devious manipulation of people and parties Giolitti tamed the extremists of all sides; socialism ceased to be a revolutionary force and was induced to cooperate with the government. Under his rule all classes in Italy enjoyed a period of great prosperity, which contributed to the feeling of national confidence of which Futurism was an expression, but Marinetti was not by any means alone in reacting against the prevailing political apathy and lack of political opposition to Giolitti and in crying out for action. A country without riots and revolts was no place for a Futurist.

Marinetti denounced socialism because it was 'international and unpatriotic'—an 'ignoble exaltation of the rights of the belly'. Futurist policy was anti-socialist, anti-clerical and anti-parliamentarian. Parliament should be 'an assembly of industrialists, agriculturalists, engineers and tradesmen'; 'Italy shall be governed by a government of twenty experts, vitalized by an assembly of young men.'

The Futurists, it goes without saying, welcomed the outbreak of the Great War, and were impatient for Italy to join in. *Lacerba* was transformed into a political journal 'with the intention of preparing the atmosphere of Italy for war'. It was in March 1915, during the campaign for Italy's intervention in the war, that

Marinetti first came into close contact with Mussolini, who as a socialist had previously disapproved of the Futurists. Marinetti's admiration of Mussolini is revealed in this description of him: 'Square champing jaws; prominent, scornful lips, which spit arrogantly and aggressively on everything that is slow, pedantic, analytical, whimpering . . . His eyes move ultra-dynamically, race as fast as automobiles on the plain of Lombardy or Italian seaplanes in the skies over the ocean; their whites flash from right to left like those of a wolf. . .'.

Marinetti was involved in the foundation of the Fascist party, but he did not for long occupy an important part in it. He was at first useful to Mussolini as an orator and agitator and for his Futurist experience of organizing demonstrations and propaganda, but by 1919 he had outlived his usefulness, and Mussolini is reported to have spoken of him as 'this extravagant buffoon who wants to play politics and whom nobody in Italy, least of all me, takes seriously'.

By this time, of course, the members of the original Futurist group had disbanded. Marinetti, although seriously wounded in the war, soon began to devote 'all intellectual, bodily and financial powers' to the second generation of Futurists. This was very much more numerous than the first. The only survivor of the original group was Balla, though some had joined the movement before the war. The members of this 'second Futurism' as it is called, were supporters of the Fascist régime. The first Futurists had demanded 'the immediate suppression of all Academies of Fine Arts—and that the state should not interfere in any way whatsoever with anything to do with art', but in 1929 Marinetti found himself, through his loyalty to Mussolini, secretary of the Fascist Writers' Union and a member of the Accademia d'Italia.

In 1920, echoing the Russian artists after the Revolution, he had written:

All power to the artists! The vast proletariat of geniuses shall govern . . . Thanks to us the time will come when life will not simply be a matter of break and toil or a life of leisure but when life will be itself a work of art . . . We shall not have heaven on earth, but our economic hell will be reanimated and soothed by innumerable festivals of art.

Тріумфъ Маринетти.

Въ Миланѣ.

Въ Москвѣ.
(Каррик. Неро.).

Futurism outside Italy

Futurism was undoubtedly an important source of ideas for contemporary painting in Europe, but most artists, understandably in view of the Italians' boastfulness and arrogant claims, were reluctant to acknowledge its influence. This was particularly true in France, where Futurism tended to be seen as a presumptuous attack on French artistic supremacy. The Futurists had their supporters there, including Félix Fenéon, and even Apollinaire, champion and theorist of Cubism, at first so scathing, came round sufficiently to write a free-word manifesto called 'The Futurist Anti-tradition'. He was obviously impressed by Futurism, and in 'The Futurists Plagiarized in France' of 1913 Boccioni accused him, with some justice, of ascribing their ideas to Orphism. Delaunay is indeed an artist whose work seems in many ways close to Futurism; the Futurists certainly profited by his example, but the influence was probably not all one way, although he, like others, angrily repudiated any association with them.

The movement met with much more whole-hearted enthusiasm, however, in Germany. The Expressionists Franz Marc and August Macke were particularly impressed: 'We shall envy Italy her sons and shall hang their works in our galleries', Marc wrote in *Der Sturm*; and Macke declared that 'Modern painting can bypass these ideas even less than Picasso'. Here their works were accepted unquestioningly as an important part of the modern movement.

Although Futurist theories were absorbed into the work of artists and writers in France and Germany, it was in Russia that the most vigorous off-shoot of Futurism grew up. Marinetti's Foundation Manifesto was apparently translated and published there very soon after its appearance in *Le Figaro* and was widely discussed. The movement was at first a literary one, led by the poet Mayakovsky and the painter and poet David Burliuk, and groups were established in Moscow and Petersburg. The Russian Futurists, however, did not wish to be associated with Marinetti's movement, and felt no need of its support. On the occasion of Marinetti's second visit to the country (the date of his first is uncertain) in 1914, those who welcomed him were accused by Klebnikov and Benedict Livsic of 'forcing Asia to bend its noble neck beneath the yoke of Europe', and Mayakovsky and others

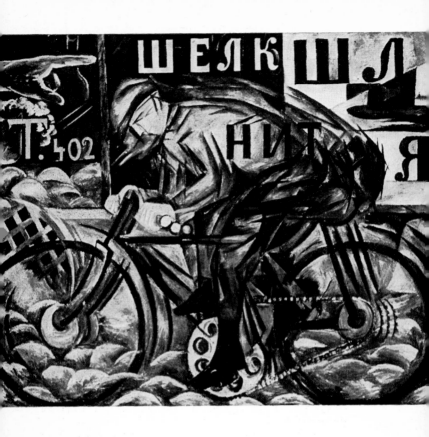

Natalia Gontcharova *The Cyclist* 1912–13 $7\frac{1}{2} \times 41\frac{3}{8}$ in. (19 × 105 cm.)
Russian Museum, Leningrad

Natalia Gontcharova *The Green and Yellow Harvest* 1912 oil on canvas
40 × 33½ in. (101·6 × 85·1 cm.)
Artist's collection, Paris

published a letter in the newspaper *Nov* in which they denied 'any debt to the Italian Futurists'.

Their manifesto of 1912 entitled 'A Slap in the Face of Public Taste' (signed by David Burliuk, Vladimir Mayakovsky and the poets Kruchenikh and Klebnikov) reveals that they had at least absorbed Marinetti's style of propaganda. In it they called for 'throwing Pushkin, Dostoevsky and Tolstoy overboard from the steamer of modern times'; they condemned the lingering traces of 'good sense' and 'good taste' in their own works, and expressed their belief in the 'new beauty of the self-sufficient and autonomous word'.

Some influence of Futurist ideas can also be seen in the works of the group of painters, including David Burliuk, Michael Larionov and Natalia Gontcharova, Alexandra Exter and Olga Rosanova, who were closely associated with the poets. Russia differed from Italy, however, in that the state of painting there at the time of the advent of Futurism was very much alive. Artists had for some time been in close contact with the latest trends in France and Germany, and Futurism was absorbed along with Cubism, Orphism and German Expressionism. They were already much more mature than the Italians, and could assimilate new ideas into their painting more completely. Whereas the Italians wanted to cut themselves off as completely as possible from their artistic heritage, the Russians drew much inspiration from their own folk art.

The short-lived movement of Larionov and Gontcharova which they called Rayonnism, was described by its authors as 'a synthesis of Cubism, Futurism and Orphism'. The Rayonnist Manifesto was published in 1913, although most of their works in this style had been produced in the previous two years. 'We declare: the genius of our days to be: trousers, jackets, shoes, tramways, buses, aeroplanes, railways, magnificent ships—what an enchantment— what a great epoch unrivalled in world history.' 'The style of Rayonnist painting promoted by us is concerned with spatial forms which are obtained through the crossing of reflected rays from various objects, and forms which are singled out by the artist.' These rays ('conventionally represented on the surface by a line of colour') can be seen as a version of the Italian Futurists' 'lines of force'. Of these two Gontcharova, with paintings such as *The Machine's Engine* and *The Cyclist*, comes closest to the themes which occupied the Italians.

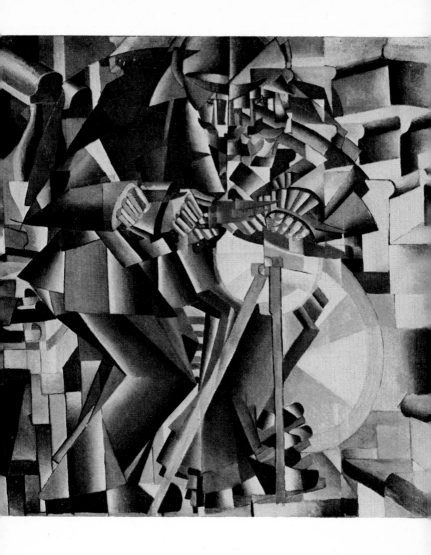

Kasimir Malevich *Scissor Grinder* 1912 oil on canvas 31¾ × 31¾ in.
(79·7 × 79·7 cm.)
Yale University Art Gallery, New Haven, Conn.

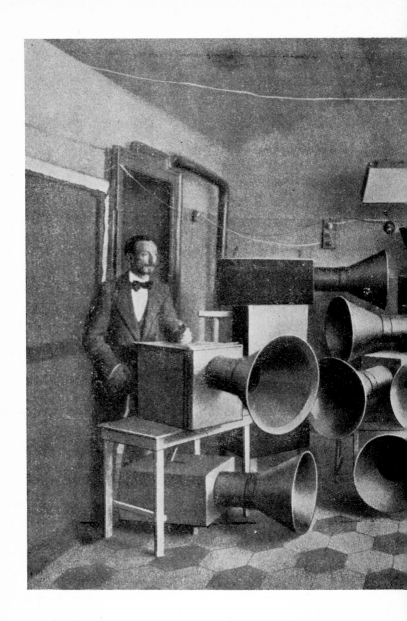

Photograph of Luigi Russolo with his Noise Organ
From 'The Art of Noises' manifesto

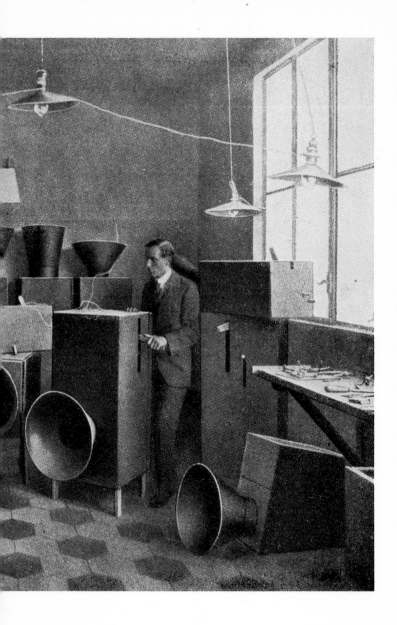

Another work in which Cubist forms are animated to convey movement and mechanical rhythms is Kasimir Malevich's picture *Scissor Grinder* of 1912 ; but although the Italian Futurists may have opened the way to such a use of Cubist technique, it is handled with much greater assurance and skill than their own attempts, and at the same time without their expressionist pre-occupations.

Like the Italians, the Russian Futurists also drew the attention of the public to themselves through their provocative and often violent behaviour. They went about wearing extraordinary costumes in brilliant colours, painted themselves with flowers and words and strange designs, and held Futurist entertainments similar to those with which Marinetti kept himself before the public eye in Italy, in which 'Non-sense' verses and manifestoes were declaimed, and plays performed. And as in Italy, these occasions frequently ended in brawls and the intervention of the police.

The Russian Futurists echoed the Italians in their conviction that the artist must no longer be cut off from life, but had a part to play. The Italian artists had wanted to 're-enter life at all costs' ; 'Art in Life !' was the slogan of the future Constructivists. In Italy the inspiration of the Futurist movement was the desire to create a new Italy ; and in Russia the advent of the revolution in 1917 brought about a state of mind in Russian artists which seems to be almost the essence of Futurism. 'We do not need', wrote Mayakovsky in a passage that brings to mind the first Futurist manifesto, 'a dead mausoleum of art where dead works are worshipped, but a living factory of—the human spirit—in the streets, in the tramways, in the factories, workshops and workers' homes.' The symphonies of factory sirens would surely have delighted Luigi Russolo, with his conviction that a new music should be made from the noises of the modern industrial city. Something of the Italians' love of constant change, movement and excitement can be felt in the description of Tatlin's *Monument to the Third International* : 'Least of all must you stand or sit in this building ; you must be mechanically transported up, down, carried along willy-nilly ; in front of you will flash the firm, laconic phrases of an announcer-agitator, further on the latest news, decree, decision, the latest invention will be announced . . . creation, only creation.'

In 1915 Balla and the newcomer to Futurism Fortunato

Francesco Cangiullo *Diaghilev and Stravinsky* (at the 'Intonarumori' evening in Marinetti's home in Milan 1914)
From *Sipario* December 1967

Depero published a manifesto called 'The Futurist Reconstruction of the Universe' which anticipates the Constructivism of Rodchenko and Pevsner, and Gabo's kinetic models of the 1920s. The manifesto explains Balla's concept of 'plastic complexes', which was both the culmination of Boccioni's experiments in sculpture and the beginning of the mechanical preoccupations of the 'second Futurism' of the postwar period.

Balla began with the study of the velocity of automobiles and discovered their laws and essential lines of force. After more than twenty pictures dealing with this investigation he realized that the single plane of the canvas did not allow the suggestion of the dynamic volume of speed in depth. Balla felt the need of constructing with wires, cardboard planes, cloth and tissue-paper etc. the first dynamic plastic complex.

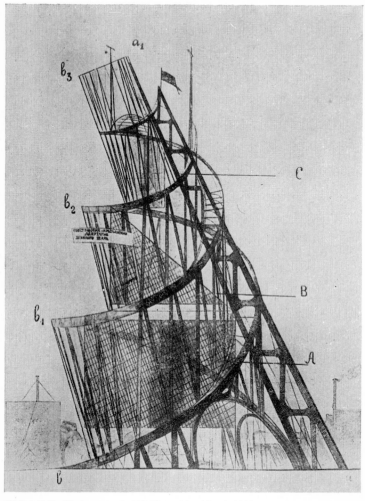

Vladimir Tatlin *Monument to the Third International* Russia 1920

Fortunato Depero, coloured 'noise-motion' (*motorarumorista*) plastic complex
of equivalents in motion 1914–15 (destroyed)
From 'Futurist Reconstruction of the Universe' manifesto 1915

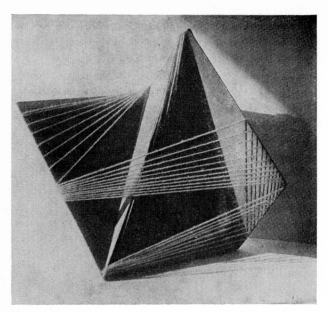

Giacomo Balla, coloured plastic complex of force-lines 1914–15 (destroyed)

None of these works survive, although some have been recon-structed from illustrations in the manifesto. Anticipating the Russians' later rejection of 'physical mass as an element of plasticity', they were to be

1 ABSTRACT. 2 DYNAMIC. Relative motion (cinemato-graphic) + absolute motion. 3 HIGHLY TRANSPARENT. For the speed and volatility of the plastic complex, which must appear and disappear. 4 HIGHLY COLOURED and HIGHLY LUMINOUS (by means of internal lights). 5 AUTONOMOUS, that is resembling nothing but themselves. 6 TRANSFORMABLE. 7 DRAMATIC. 8 VOLATILE. 9 ODOROUS. 10 NOISY . . . 11 EXPLODING, simultaneously appearing and disappearing in bursts.

Italian Futurist experiments in the expressive use of typography also foreshadow the work of El Lissitsky and others in the early

years of the Revolution, and there are close connections between the two countries in the field of the theatre. 'Russian stage-design', wrote the Minister for Culture, Lunacharsky, 'has been directly influenced by Italian Futurism.' The Italians really began to develop their ideas about the theatre after the Great War when the 'first Futurism' with which this account deals was over, and the 'second Futurism' grew up around the figures of Balla, Prampolini, Depero, Bragaglia and others, but Marinetti's most important writings on the subject, 'The Variety Theatre' and 'The Futurist Synthetic Theatre' were published in 1913 and 1915 respectively. Alexandra Exter, an important pioneer in the Russian theatre, is known to have visited Italy several times and to have been in touch with Boccioni (who experimented in this field) and the other Futurists, and her development of the system of 'Synthetic Theatre' in the productions of the Kamerny Theatre from 1916 presumably reflects their ideas. The Italian experiments with stage design were a continuation, broadly speaking, of the painters' aim of putting the spectator 'in the centre of the picture' and centred round ways of involving the audience in the action, ideas developed in the twenties in Meyerhold's Constructivist productions.

Futurism also had a stimulating effect on English art. It was much discussed in English literary and artistic circles, newspapers were full of it, and literary reviews devoted whole numbers to its discussion. Marinetti visited the country several times, and his visits were enlivened by the usual incidents and dissensions. In 1911 he challenged the journalist Francis McCullagh to a duel for accusing the Italians of piracy in their campaign in Tripoli. In 1914 Russolo gave a recital on his 'Noise organ' at the Coliseum. The recital was not a success: 'it must have sounded magnificent to him, for he beamed, but a little way back in the auditorium all one heard was the faintest of buzzes'. But such events inevitably created something of a stir.

VORTEX.

POUND.

The vortex is the point of maximum energy,

It represents, in mechanics, the greatest efficiency.

We use the words " greatest efficiency " in the precise sense—as they would be used in a text book of MECHANICS.

You may think of man as that toward which perception moves. You may think of him as the TOY of circumstance, as the plastic substance RECEIVING impressions.

OR you may think of him as DIRECTING a certain fluid force against circumstance, as CONCEIVING instead of merely observing and reflecting.

THE PRIMARY PIGMENT.

The vorticist relies on this alone ; on the primary pigment of his art, nothing else.

Every conception, every emotion presents itself to the vivid consciousness in some primary form.

It is the picture that means a hundred poems, the music that means a hundred pictures, the most highly energized statement, the statement that has not yet SPENT itself it expression, but which is the most capable of expressing.

THE TURBINE.

All experience rushes into this vortex. All the energized past, all the past that is living and worthy to live. All MOMENTUM, which is the past bearing upon us, RACE, RACE-MEMORY, instinct charging the PLACID, NON-ENERGIZED FUTURE.

The DESIGN of the future in the grip of the human vortex. All the past that is vital, all the past that is capable of living into the future, is pregnant in the vortex, NOW.

Hedonism is the vacant place of a vortex, without force, deprived of past and of future, the vertex of a stil spool or cone.

Futurism is the disgorging spray of a vortex with no drive behind it, DISPERSAL.

153

Wyndham Lewis *The Vorticist* 1912 ink, wash and pastel $16\frac{1}{2}$ × 12 in.
(41·9 × 30·5 cm.)
Southampton Art Gallery

C.R.W.Nevinson, study for *Returning to the Trenches* 1914–15 charcoal and crayon 5¾ × 8⅛ in. (14·6 × 20·6 cm.) Tate Gallery, London

In 1914 Marinetti was welcomed by the painter C.R.W.Nevinson (who was a friend of Severini) and Wyndham Lewis at a banquet attended by sixty guests including Harold Monro, Laurence Housman, and R.Wilenski, during which 'Marinetti recited a poem about the siege of Adrianople with various kinds of onomatopoeic noises and crashes in free verse, while all the time the band downstairs played "You made me love you. I didn't want to do it".' Marinetti lectured the English on their national vices and virtues; he admired their 'indomitable and bellicose patriotism', and their passion for boxing ('simple, brutal and swift'), but condemned 'the lymphatic ideology of your deplorable Ruskin . . . with his nostalgia for Homeric cheeses . . . with his hatred of the machine' and 'the obsessional cult of our past [which has] entirely perverted your judgement of contemporary Italy'. During this visit Nevinson wrote a Futurist manifesto

entitled 'Vital English Art', signed by himself and Marinetti. It was published in *The Times,* the *Observer* and the *Daily Mail*, and was scattered down on audiences at the theatre. Battle was to be waged against

Worship of tradition and the conservatism of Academies, the commercial acquiescence of English artists, the effeminacy of their art. The pessimistic, sceptical and narrow views of the English public, who stupidly prefer the pretty-pretty, the commonplace, the soft, sweet and mediocre. The sickly revivals of mediaevalism, the Garden Cities with their curfews and artificial battlements, the Maypole Morris dancers, Aestheticism, Oscar Wilde, the pre-Raphaelites, neo-Primitives, and Paris. The perverted snob who ignores all English originality and daring but welcomes eagerly all foreign originality and daring . . . The indifference of the King, the State and the politicians towards all arts. The English notion that Art is a useless pastime, only fit for women and school-girls, that artists are poor deluded fools to be pitied and protected, and Art a ridiculous complaint, a mere topic for table-talk. The sentimentality with which you load your pictures, to compensate, perhaps for your praiseworthy utter lack of sentimentality in life. The Mania for immortality. A masterpiece must disappear with its author. . . .

The manifesto ended with a call for an English art 'that is strong, virile and anti-sentimental' and an explosion of Futurist excitement: 'Forward! Hurrah for motors! Hurrah for speed! Hurrah for draughts! Hurrah for lightning!'

Wyndham Lewis hastened to disclaim any connection with this manifesto, and resolutely declined, despite Marinetti's coaxing, to call himself a Futurist. Nevertheless, his movement, Vorticism, was the most important offshoot of Futurism in England. Lewis called Vorticism a 'counter-*putsch*' to Futurism, but his magazine *Blast,* which appeared in July 1914 and July 1915, clearly reflects Marinetti's propagandist style, and the general tone of Futurist writings. It contained poems, plays, manifestoes and 'outbursts of one sort and another', and illustrated the works of Lewis himself, together with those of Wadsworth, Gaudier-Brzeska, William Roberts, Epstein and others of the Vorticist Group. Vorticism, Wyndham Lewis later wrote, 'hustled the cultural Britannia, stepping up that cautious pace with which she prefers

BLAST First (from politeness) ENGLAND

CURSE ITS CLIMATE FOR ITS SINS AND INFECTIONS

DISMAL SYMBOL, SET round our bodies,
of effeminate lout within.

VICTORIAN VAMPIRE, the LONDON cloud sucks
the TOWN'S heart.

A 1000 MILE LONG, 2 KILOMETER Deep

BODY OF WATER even, is pushed against us

from the Floridas, TO MAKE US MILD.

OFFICIOUS MOUNTAINS keep back DRASTIC WINDS

SO MUCH VAST MACHINERY TO PRODUCE

THE CURATE of "Eltham"
BRITANNIC ÆSTHETE
WILD NATURE CRANK
DOMESTICATED
POLICEMAN
LONDON COLISEUM
SOCIALIST-PLAYWRIGHT
DALY'S MUSICAL COMEDY
GAIETY CHORUS GIRL
TONKS

11

First page of First Vorticist Manifesto
From *Blast* no. 1, 20 June 1914

William Roberts *Dancers*
From *Blast* no. 1, 20 June 1914

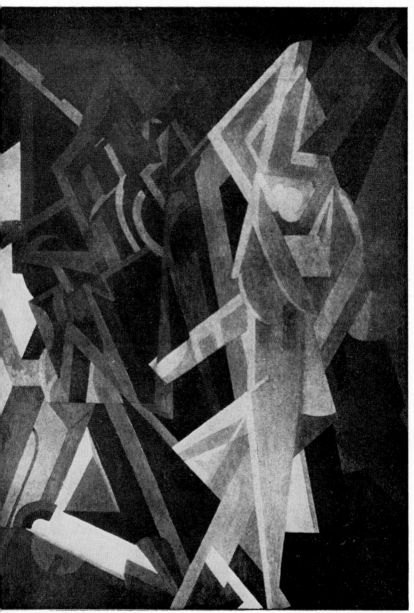

Giacomo Balla and Francesco Cangiullo *Palpavoce* free-word composition
1914

to advance'; it was the first school of abstract painting in England, based on Cubism, 'hard, clean and plastic', but combining it with the Futurist concept of dynamic movement. The Vorticist Group held an exhibition in 1915, in which David Bomberg took part, but in painting the movement did not survive the Great War. Nevinson's paintings of the war are influenced by Futurism, but for him, as for so many others, Futurism was only a brief phase of his youthful development. Vorticism was also a literary movement; its major manifesto, 'The Great Vortex', was signed by writers as well as artists, including Richard Aldington and Ezra Pound, who invented the movement's name. Pound vouches for the lasting importance of Futurism in literature in this surprisingly generous tribute: 'Marinetti and Futurism have given a great impetus to all European literature. The movement to which Joyce, Eliot and myself have given birth in London would not have existed without Futurism.'

The Dada movement which grew up in Switzerland in 1915 has also acknowledged its debt to Futurism. 'Like all new-born movements,' writes Hans Richter, one of the original members of the group, 'we were convinced that the world began anew with us; but in fact we had swallowed Futurism—bones, feathers and all.' By 1915, as we have seen, the spirit of the Italian Futurists had begun to flag, and the group to break up; the Dadaists seem to have taken over where the Futurists left off.

'Proto-Dada' elements had made their appearance in the writings of Marinetti and his followers quite early on. The 'anti-art' mood can be seen in Russolo's 'Art of Noises', a musical response to Marinetti's exhortations in his 1912 Manifesto of Futurist Literature to make use of 'all brutal sounds, all expressive screams of the violent life which surrounds us . . . [to produce] the "ugly" . . . and to Kill solemnity everywhere'. A similar spirit is evident in the tone of Carrà's 'Painting of Sounds, Noises and Smells', and in the poet Aldo Palazzeschi's manifesto 'Il Controdolore' in which man is encouraged to discover the maximum amount of laughter in grief, and 'the man who suffers, the man who dies are the largest sources for human joy'. Perhaps the most direct anticipation of Dadaism was contained in Marinetti's 'Variety Theatre' manifesto, which advocated the systematic prostitution of all classic art on the stage: a Beethoven symphony played backwards; all Shakespeare reduced to one act, etc.

Marinetti contributed to *Cabaret Voltaire,* the first Dada brochure,

Landscape in a Thunderstorm example of visual poetry

in 1916, and he and Tristan Tzara remained in close contact. The Dada *soirée*, with its reading of 'Bruitist' and 'Simultaneist' poems and its cabaret technique, was more or less identical with the Futurist entertainments with which Marinetti had been outraging the public for years. The Futurist spirit can be seen clearly in this description of the Bruitist poem (Dadaist Manifesto, Berlin 1918): 'The Bruitist poem represents a streetcar as it is, the essence of the streetcar with the yawning of Schulze the *rentier* and the screeching of brakes', and indeed the combining of poetry and noises, and the simultaneous reading of poems were both taken over from Futurism. The Dadaists also made great use of the Futurist manifesto, declaimed from the stage or distributed as broadsheets, and the layout of these documents, and of Dada posters, employs the typographical devices invented by the Futurists. Hans Richter also gives Futurism as the source of the Dada phonetic poem, which he says originated in Marinetti's 'parole in libertà', and of Dada's photomontage, which, he writes, 'was basically no more than a "correct" application of the "realistic" Futurist principle of assembling suggestive documentary items to produce an all-embracing, dynamic pattern of the interpenetrating aspects of reality'. But the most striking similarity between the two movements is the desire to shock, to do violence to bourgeois sensibilities.

Photograph of Sant'Elia, Boccioni and Marinetti, 1915

152

Conclusion

For the Futurists war was the highest, the most perfect activity, and it seems fitting that their movement should have been consumed in the holocaust. Boccioni, Marinetti, Russolo and Sant'Elia all enlisted at the first opportunity in the Volunteer Cyclists, and all of them were distinguished for their bravery. Marinetti (twice decorated) and Russolo, were both severely wounded, and Russolo never fully recovered. Sant'Elia was killed in action; Boccioni, who in 1915 wrote from the front: 'War is a wonderful, marvellous, terrible thing! In the mountains it . . . seems like a fight with the infinite. Grandiosity, immensity, life and death! I am happy!', died the following year after falling from a horse. By 1914 the group had already begun to lose its cohesion. By 1916 two of its most talented members were dead; in that year Carrà met Giorgio de Chirico and turned from Futurism to Metaphysical painting; and the original Futurism had definitely run its course.

In *Blast,* July 1915, Wyndham Lewis wrote: 'The war has exhausted interest for the moment in booming and banging. I am not indulging a sensational prophecy of the disappearance of Marinetti. He is one of the most irrepressible figures of our time, he would take a great deal to discourage . . . If human being was ever quite happy and in his element it was Marinetti imitating the guns at Adrianople. . . .' Marinetti did indeed soldier on; but the 'second Futurism' which grew up in the twenties, although it kept alive some of the early Futurist ideas, added little that was new, and nothing of importance. It was the Dada movement which took over and developed the role of Futurism in art.

A journalist once described Marinetti as 'the caffeine of Europe', and Futurism left its mark on literature and art rather through the stimulating effect of its theories than the example of the works it produced. It helped to awaken in artists and writers a new sense of the aesthetic possibilities of the modern world; it expressed the widespread contemporary reaction against what Ezra Pound called the 'emotional slither' of romanticism. In a letter of 1914 D.H.Lawrence writes of Futurism: 'I like it because it is the applying to emotions of the purging of the old forms and sentimentalities. I like it for its saying—enough of this sickly cant, let us be honest and stick by what is in us.'

Wyndham Lewis, frontispiece of *Blast* War Number, July 1915

In his Foundation Manifesto Marinetti had given the Futurists ten years to achieve their ends. In the event the movement was over before that time was up. For better or worse they had helped to put Italy politically on the map; and they had certainly brought her, with a splash, into the mainstream of European art.

In their insistence on breaking down the barriers between the individual arts; their belief that any materials, however unconventional, could be used in the creation of works of art, and that these works would quickly be made obsolete by new inventions; their idea of 'the art of the becoming, the perishable, the transitory and the expendable'; and their over-all realization that new artistic forms were needed to express the new conditions of life, the Futurists not only expressed a feeling that was in the air at the time, but anticipated a whole line of development which is still unfolding today. They were so fruitful of original ideas, so occupied with the business of expressing them in words and making them widely known, and so side-tracked by their feelings of artistic and national inferiority, that it is little wonder that it was left for others to put their theories into practice.

Book list

Banham, Reyner *Theory and Design in the First Machine Age*, London : Architectural Press ; New York : Praeger 1960

Carrieri, Raffaele *Futurism*. Milan : Edizioni de Milione n.d.

Clough, Rosa Trillo *Futurism. The Story of a Modern Art Movement. A New Appraisal.* New York : Wisdom Library 1961

Drudi Gambillo and Teresa Fiori, eds. *Archivi del Futurismo*. Rome : De Luca, Vol. 1 1958, Vol. 2 1962

Joll, James *Intellectual in Politics*. London : Weidenfeld and Nicolson 1960

Martin, Marianne W., *Futurist Art and Theory, 1909–1915*. Oxford : Clarendon Press 1968

Taylor, Joshua C. *Futurism.* New York : Museum of Modern Art 1961

Index

(Page numbers in italics refer to illustrations on those pages)

STUDIO VISTA | DUTTON PICTUREBACKS

edited by David Herbert